THE CHESTER & HOLYHEAD RAILWAY

The Modern Scene

Richard Billingsley

I'd like to dedicate this work to my Dad; sadly he passed in 2016, but none of this would have happened if he hadn't put a camera in my hand and sent me packing. Thanks Dad.

Richard Billingsley

First published 2018

Amberley Publishing
The Hill, Stroud
Gloucestershire, GL5 4EP

www.amberley-books.com

Copyright © Richard Billingsley, 2018

The right of Richard Billingsley to be identified as the Author of this work has been asserted in accordance with the Copyrights, Designs and Patents Act 1988.

ISBN 978 1 4456 8525 0 (print)
ISBN 978 1 4456 8526 7 (ebook)

British Library Cataloguing in Publication Data.
A catalogue record for this book is available from the British Library.

Origination by Amberley Publishing.
Printed in the UK.

Introduction

Think of the North Wales Coast Mainline and you may conjure an image of hundreds of Edwardian travellers, pouring from the stations at Rhyl, Colwyn Bay or Llandudno, heading for the beach in their top hats, bonnets and Sunday best.

Or maybe you'll recall the 1970s and '80s, the Indian summer of the holiday train, long rakes of dusty blue and grey stock, headed by a locomotive more at home serving steel works or power stations, the families of industrial Britain heading away for the factory fortnight, chips on the prom and a pint or two to wash them down.

The line's existence is almost entirely due to the early Victorian desire to improve communication with Dublin and the Irish Republic, 65 miles west across the water from the Isle of Anglesey. At the time, the mails were conveyed by stagecoach along Telford's turnpike as far as Holyhead before completing the journey by steamship to Dublin, a near three-day trek.

The completion of the Grand Junction Railway opened England's north-west up to the London & Birmingham Railway; the Irish Mails were diverted to Liverpool and thence by steam packet across the Irish Sea. This reduced the journey to around 24 hours, but the sea crossing was too long, so approval was sought for a railway to link Chester and Holyhead, Chester already being served by a link to the Grand Junction Railway at Crewe.

Passed by Parliament in 1844 and fully opened by 1850, the Chester & Holyhead Railway allowed through trains from London Euston to reach North Wales and deliver the mails to Holyhead; this reduced the sea crossing by more than half. The Irish Mail was born.

Over its 168-year existence, the line has handled all manner of traffic, not just mails and holidaymakers. As the ships and trains improved over time, the journey from Dublin to London further shrank and a new market for people travelling between the Irish Republic and the UK became quickly established, a market that remained buoyant right up until the advent of the low-cost air carriers in the 1980s. There would often be five trains awaiting the arrival of the ferry at Holyhead: three for London and one each for Birmingham and Manchester.

The modern railway that has evolved from this history is barely recognisable from that of 130 years ago; the past thirty years have seen enormous change. The mail is no longer taken by train (it now flies to Dublin in an hour from London) and freight traffic is almost gone too – even the Freightliner container terminal at Holyhead closed in 1991. Passenger traffic has boomed, though; the once sparse service to Holyhead is at least hourly for most of the day, and future service development means the eastern section of the line from Chester to Llandudno Junction will see at least three trains

each way every hour, with through services from London, Birmingham, Manchester, Liverpool and Cardiff.

The most noticeable change, certainly for the enthusiast, is in the motive power and rolling stock. In common with the rest of Britain, less frequent, long trains of locomotive-hauled stock have given way to higher frequency but shorter trains formed by multiple units. While these trains cope well enough with the day-to-day traffic using the line, the service on offer quickly becomes overrun at peak times, especially during school holidays and summer weekends, the two and three car units unable to cope with the sheer number of people wanting to travel.

The period covered in this book is from mid-2009 to early 2018, and features photographs from the entire line, as well as the branches to Llandudno Town and Blaenau Ffestiniog. During this period, Virgin Trains has ended locomotive haulage of its Pendolino trains and all its services are now operated by Voyager units. Arriva Trains Wales has been the principal operator on the line since 2003, using Class 150, 158 and 175 multiple units along with two sets of locomotive-hauled Mark 3 stock powered by Class 67 locomotives. Used for timetabled work in the week, the hauled sets are used on relief work as needed at weekends; the Crewe-based set sees summer Saturday extra work to Llandudno and Holyhead, while the Holyhead-based train is often used to take participants to events in the Millennium Stadium in Cardiff.

North Wales remains a favoured destination for charter train operators, West Coast Railways being the most prominent. Most months of the year will see at least one charter train visit the line, and steam locomotives can often be seen. The North Wales Coast Express runs from Liverpool to Holyhead on some summer Sundays, which utilises some of the larger preserved steam locomotives between Crewe and Holyhead. There's variety for the diesel fan too: during the period covered by this book, railtours and charters have brought ten different classes of diesel locomotive to the line, including some that would never have operated in the area before.

Sadly, the decline of freight traffic is almost complete. Steel traffic to Mostyn Docks ceased in 2010, and the once regular flow of ballast from the quarry at Penmaenmawr has also ended – the last rail flow took ballast to Guide Bridge for use on the Manchester Metrolink extensions. Both terminals are still connected to the rail network; indeed, the connection to Mostyn Docks has recently been renewed in hope of future traffic. The last remaining regular flow is the nuclear flask traffic from Wylfa power station on Anglesey's north coast. There is no inbound traffic any longer – the site ceased generating in 2015 – but three trains a week continue to collect flasks filled with used fuel rods. Operated by Direct Rail Services, the trains were dominated by Class 37 haulage for some years, but in May 2017 the new Class 68 locomotives were deployed on the service.

The current projection is that all the fuel rods will be removed from Wylfa by the end of 2019. A new nuclear station is planned for construction alongside the now closed one, although with a projected ten-year build time it's inevitable that there will be a gap of some years before the nuclear workings restart.

Infrastructure trains, test trains and the railhead treatment train add the final layer of variety to the North Wales Coast scene. Both Colas Rail Freight and Freightliner provide trains to maintain track and signals, bringing Class 56, 60, 66, 67 and 70 locomotives to the area. The autumnal railhead treatment trains have seen three operators and five different loco types and has become a firm enthusiast favourite

with its current use of Colas Class 56s. Colas also provide Class 37 and 67 locos to operate test and infrastructure monitoring trains, and the Network Rail HST-based New Measurement Train has a scheduled four-weekly trip along the line.

I've taken all the images used in this book and I hope they inspire people to visit the area and see what it has to offer. I'm sure that many might think that the current scene is a little dull in comparison to years gone by; that may be so – the heyday of the diesel locomotive-hauled passenger train has long since passed. There is still plenty to see and photograph however, and with Mark 4 locomotive-hauled trains starting in 2020, new photo opportunities are still to come.

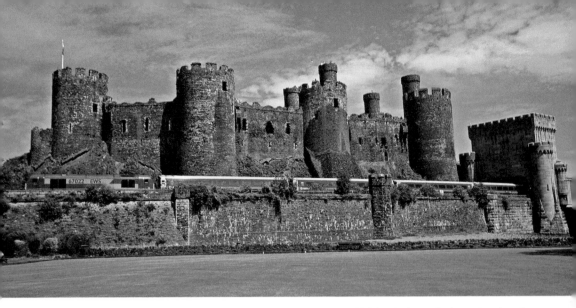

DB Cargo-owned Class 67 No. 67022 leads 1D34, Manchester Piccadilly to Holyhead, alongside the medieval castle at Conwy on 10 July 2015. The locomotive-hauled set visits both Holyhead and Llandudno during its working day and consists of the locomotive, four Mark 3 standard coaches and a Mark 3 driving van trailer (DVT).

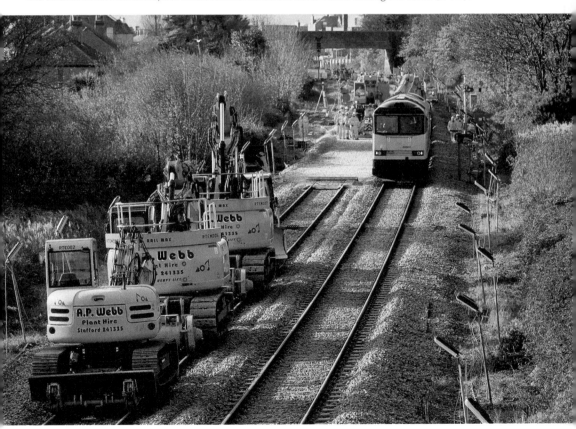

During the latter part of 2017, work started to install bi-directional signalling between Flint and Rhyl. Colas Rail Freight-owned Class 60 No. 60002 had delivered part of a new crossover to the worksite at the new Rhyl East Junction and was involved in the installation on 12 November 2017.

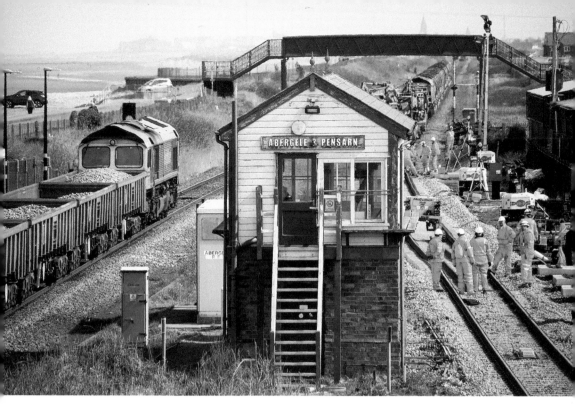

Engineers on a day out to the seaside at Abergele and Pensarn. During the early part of 2017 the down loop at the station was abolished and the platform widened out to the down main. The work wasn't completed until 8 April 2018 when the points were finally removed. Locomotives No. 66519 and No. 66590 were among the Freightliner Class 66s involved in the work.

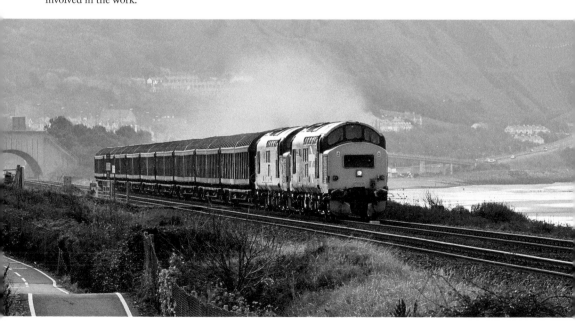

Thunder in Penmaenmawr Bay as Class 37s No. 37425 and No. 37401 lead 6F18, Anglesey Aluminium to Warrington Arpley Cargowaggons, on 31 October 2009. After closure of the smelter at Holyhead the previous month this was the final time that this train ran, its cargo of aluminium ingots bound for Austria.

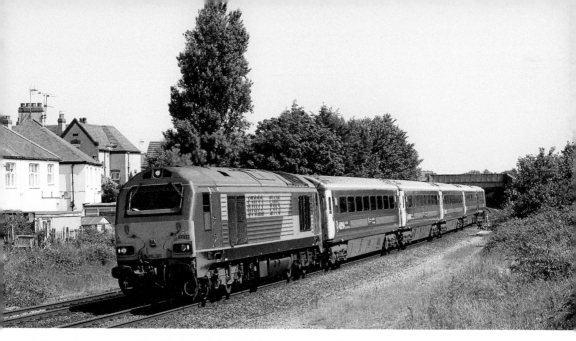

Still wearing its original English, Scottish & Welsh Railway colours, No. 67022 heads west from Rhyl with 1D34, Manchester Piccadilly to Holyhead, on 6 July 2017. Currently, the two Welsh diagrams are the only scheduled passenger work for the class.

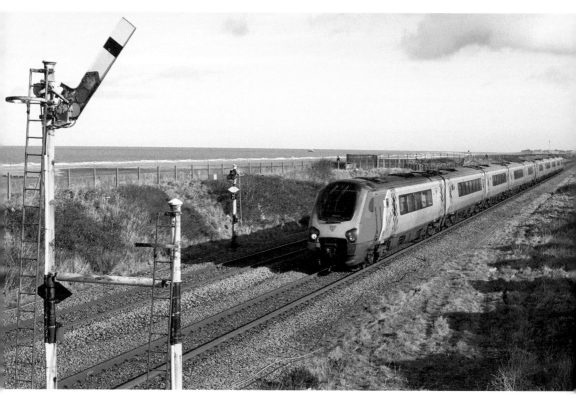

With just a few weeks' service left, the remaining semaphore signals at Abergele and Pensarn are passed by two Virgin Voyagers forming the 1D83 London Euston to Holyhead train on 7 February 2018. The bare right post on the signal in the foreground formerly carried the signal controlling entry into the down loop, abolished a year previously.

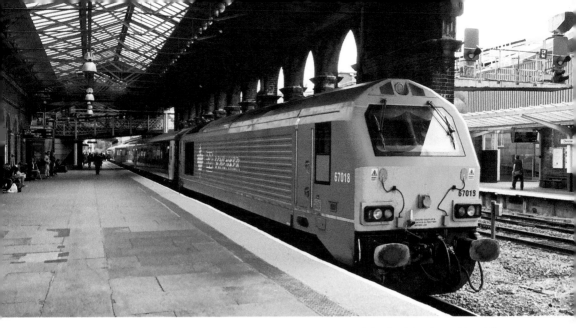

On 2 September 2017, Platform 4 at Chester hosts No. 67018 on 1H89 Holyhead to Manchester Piccadilly, powering the train from the rear. Chester is the gateway to the North Wales coast, with routes converging from Liverpool, Manchester, Crewe and Shrewsbury as well as the coast. The station buildings were the original headquarters of the Chester & Holyhead Railway.

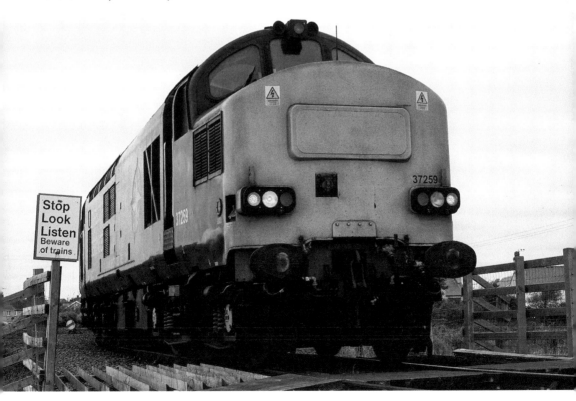

Direct Rail Services-owned Class 37 No. 37259 on the Valley triangle at Anglesey on 26 October 2016. The triangle is the origin point of the nuclear flask workings to Crewe; the flasks arrive here from Wylfa power station, 12 miles away by road.

Llandudno Junction sees a steady stream of Class 158 units daily, but it's rare for them to look like this. First Great Western unit No. 158763 visited with a special working from Exeter in association with the Association of Community Rail Partnerships conference in Llandudno on 28 September 2013 and is seen stabled in the old horse dock at Junction station.

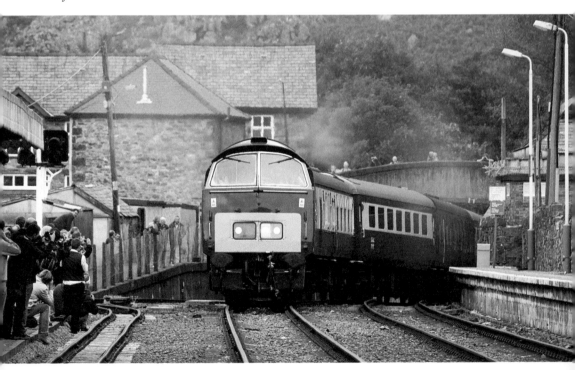

The southern terminal of the Conwy Valley line is Blaenau Ffestiniog; its connection with the Ffestiniog Railway makes the branch a frequent destination for charter trains from around the country. On 20 September 2009, it was the turn of preserved Class 52 D1015 *Western Champion* to visit with the Western Slater railtour from Didcot. The train enters the stabling loop at the joint Network Rail/Ffestiniog Railway station.

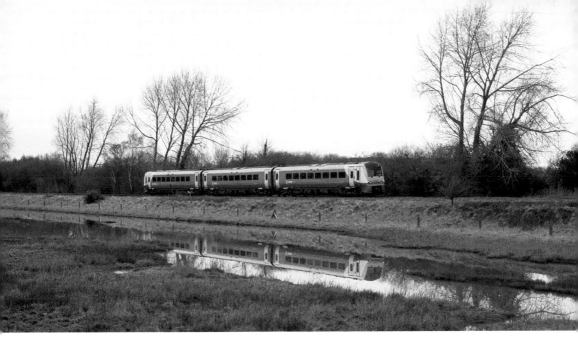

The salt marshes at Bagillt reflect a Class 175 unit as it runs east on an afternoon Llandudno to Manchester service on 21 February 2018. The class replaced Class 37-hauled workings at around the turn of the century and has been the backbone of long-distance services in Wales ever since.

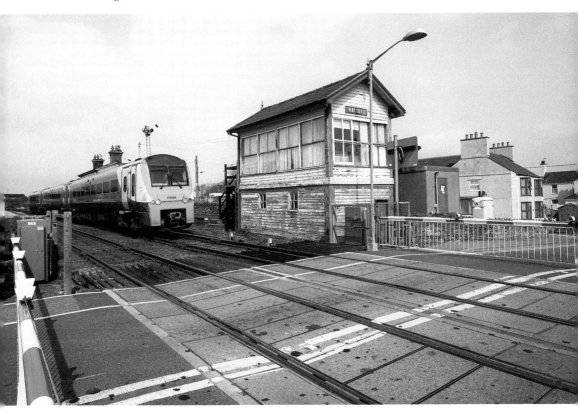

Class 175 unit No. 175104 passes Valley station and signalbox working the daily Holyhead to Maesteg train on 11 April 2018. Sadly, the 150-year-old veteran signalbox is showing its age despite its Grade II listed status.

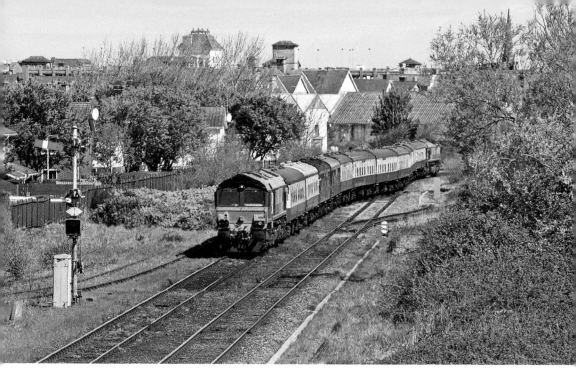

Top and tail DB Schenker Class 66s arriving at Llandudno on 3 May 2010. The charter train had originated at London Euston and was hauled to Crewe via Northampton by an electric Class 90 locomotive. As the train was too long to be stabled, the lead locomotive was detached and left in Platform 2 while the rest of the train was shunted to Platform 3.

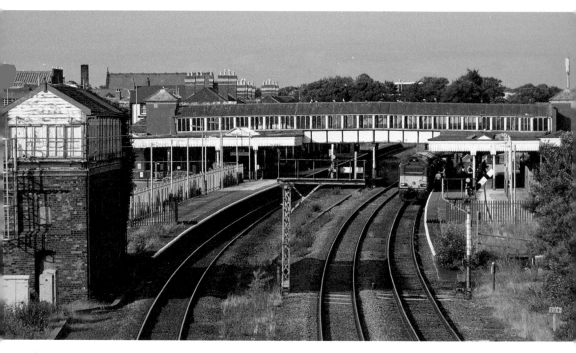

On 8 July 2015, Class 67 No. 67022 calls at Rhyl with 1D31, the Manchester Piccadilly to Llandudno service. The locomotive-hauled set, nicknamed the Manwag, was introduced to boost seating capacity on peak hour Manchester trains and released a Sprinter unit to allow another service to double up.

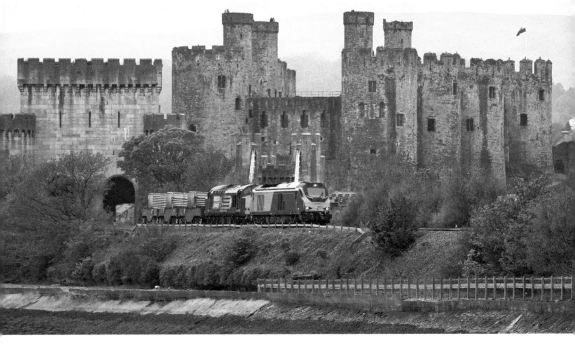

While Class 37s were the usual power, up until May 2017 virtually any pairing of Direct Rail Services locomotives could turn up on the Valley flasks. From that time, Class 68 have been used on every one of the workings except one. An unusual pairing on 6 May 2016 saw Chiltern-liveried No. 68011 pair up with No. 37259 on 6K41, Valley to Crewe; the pair are seen with Conwy Castle as the backdrop.

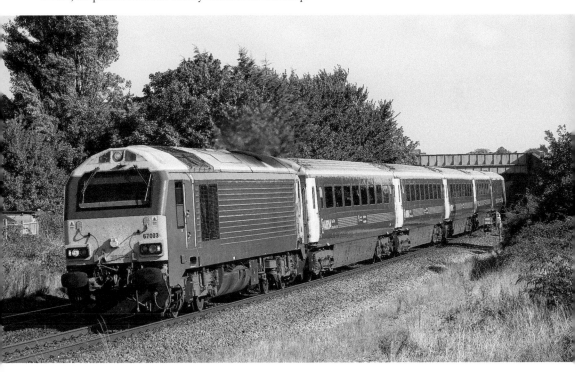

In 2011 DB Schenker painted three of its Class 67 locomotives in a plain blue livery to match the Mark 3 coaching stock they were destined to haul. The trio, Nos 67001/002/003, don't often show up in practise and No. 67003 is a very unusual sight along the coast. The livery looks smart on a full train, as shown by No. 67003 on one of its rare visits to Rhyl on 5 October 2016. The side panel under the cab window has obviously been borrowed from another loco.

Based at Shrewsbury Coleham depot, the Colas-operated railhead treatment train for North and Mid Wales uses Class 56s for the main part of its itinerary and its daytime run to Holyhead and back makes it a popular train with photographers. Previously, the Network Rail Class 97s were used throughout. Above, No. 97303 stands out against Colwyn Bay as it heads home on 29 November 2014.

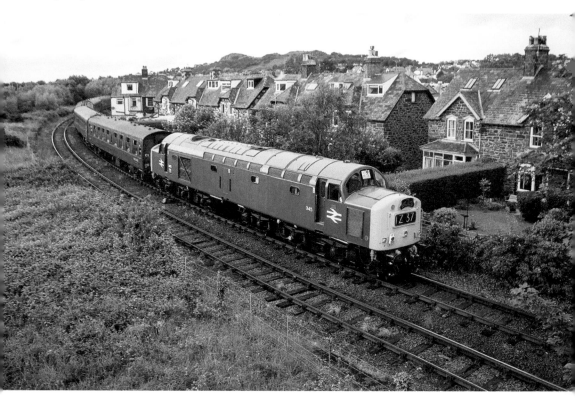

Once an everyday sight on the Deganwy curve, Class 40 locomotive 345 (No. 40145) rides on the rear of the East Lancs Enterprise tour on 10 June 2017. The Class 40 locomotives were long associated with the North Wales coast and became regular performers right up until the final withdrawal of the class in the mid-1980s.

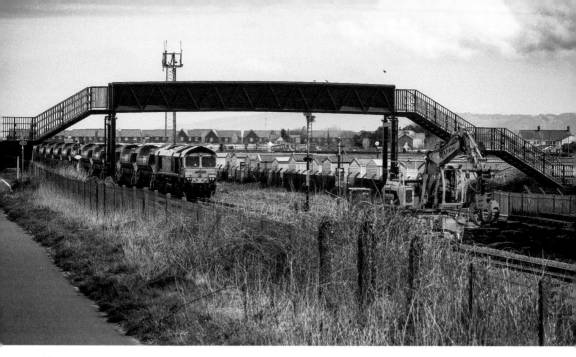

Track replacement work at Abergele and Pensarn on 8 April 2018. Freightliner Class 66 No. 66590 waits with a train of auto-ballasters while a mechanical grab sorts the piles of removed track components for removal.

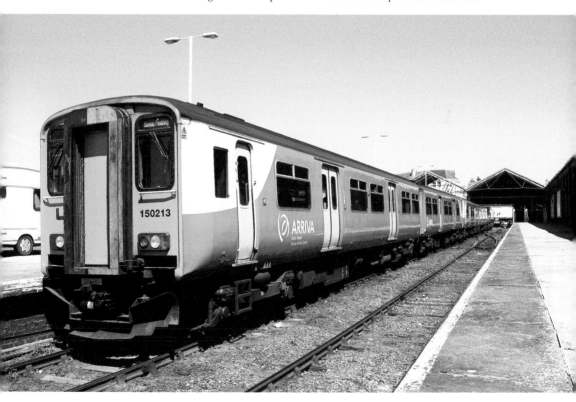

A busy weekend for the Conwy Valley train using two Class 150 Sprinters rather than the usual one. Nos 150213 and 150264 have arrived full and with people standing from Blaenau Ffestiniog on 3 May 2010 during the annual Llandudno Victorian Extravaganza held during May Day weekend.

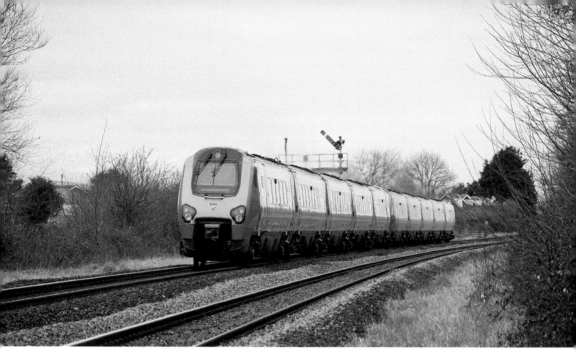

The main morning London to Holyhead service is 1D83, which operates with two Voyager units. Until 2011, the train was operated by a Pendolino unit dragged by a Class 57 locomotive. The train heads west through Prestatyn on 21 March 2018 during the last week of semaphore signalling in the area.

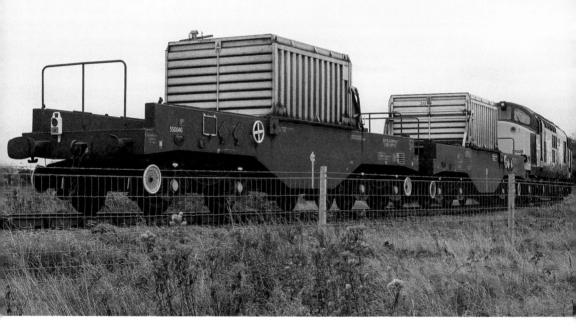

A closer look at the FNA nuclear flask carriers. After arrival from Wylfa power station, the flasks are craned from the lorry to the train, which then takes the flasks to Crewe. From there, the flasks go to the Sellafield nuclear site and the contents are reprocessed. On 26 October 2016, Nos 37038 and 37259 get ready for departure from Valley with 6K41 to Crewe.

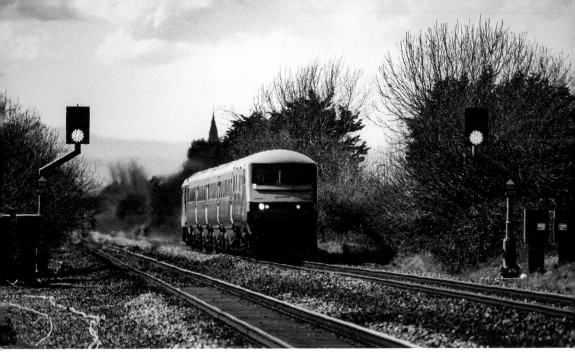

The new signalling system at work on 5 April 2018. The 1H89 Holyhead to Manchester Piccadilly service has entered the bi-directional section between Rhyl and Flint with Class 67 No. 67015 powering from the rear. Line speed here is 90 mph under normal running, but only 50 mph if running bi-directionally.

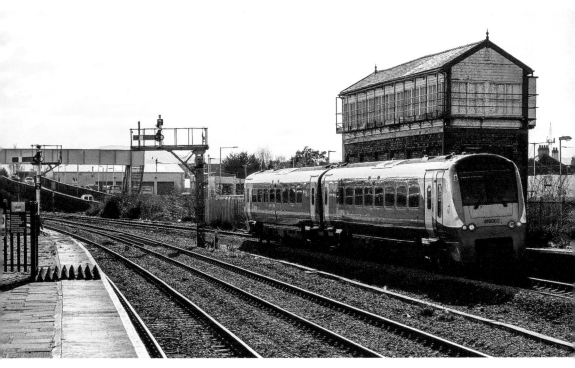

Disused since 1990, Rhyl No. 2 signalbox stands at the west end of the station, its Grade II listed status preventing its demolition. The adjacent signals were controlled by Rhyl No. 1 signalbox, situated at the other end of the station, and were in their last week of service on 19 March 2018 as Class 175 unit No. 175002 passed on an afternoon Manchester service.

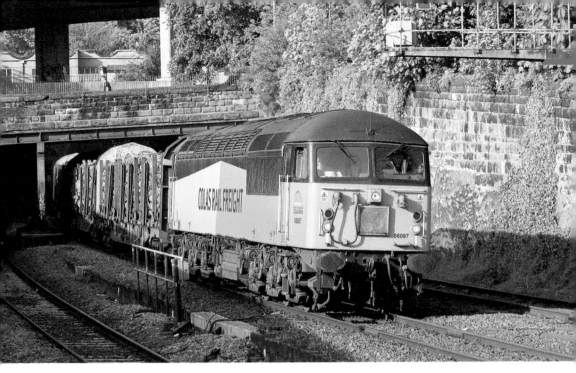

A popular working with enthusiasts in the area is 6J37, the Carlisle to Chirk log train. Operated by Colas Rail Freight for some years, the train used Virgin-liveried Class 57s for a time before Class 47 then Class 56 haulage took over. No. 56087 powers the train through the city walls at Northgate Lock on the west side of Chester on 17 May 2014. More recently, the train has been hauled by Class 60 locomotives.

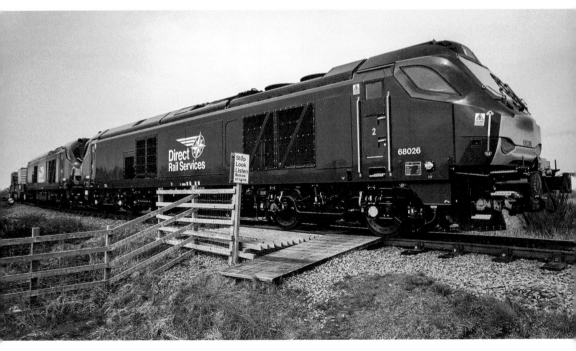

The new norm on the Valley flasks is pairs of Class 68 locomotives and on 11 April 2018, Nos 68026 and 68030 reverse away from the Valley triangle with 6K41 to Crewe. Both locomotives carry the plain blue basic DRS livery and are destined for passenger service with TransPennine Express in 2019.

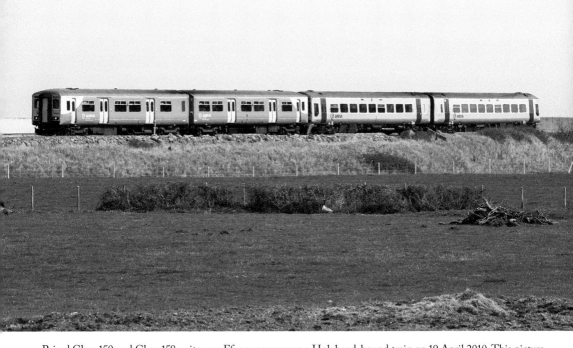

Paired Class 150 and Class 158 units pass Ffynnongroyw on a Holyhead-bound train on 19 April 2010. This picture dates from the time when a volcanic ash cloud was causing many European air schedules chaos and trains to the port were strengthened to carry extra passengers whose flights to Ireland had been cancelled.

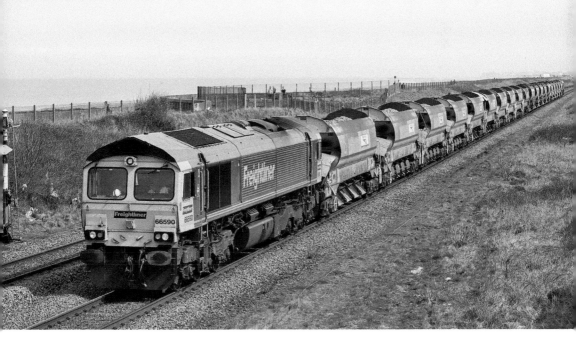

Ready and waiting, Class 66 No. 66590 sits with fresh ballast at Abergele and Pensarn on 8 April 2018. Another Class 66 tails the train and in the far distance behind a Colas Rail track tamper awaits its turn of duty.

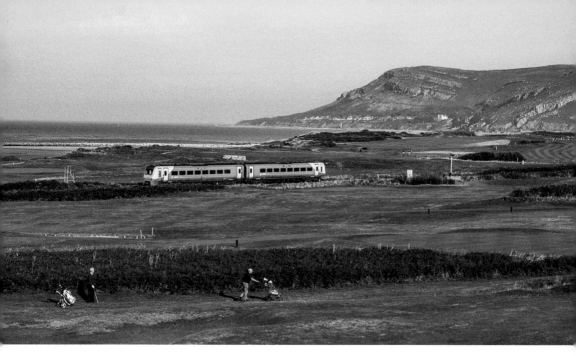

Unnoticed by early morning golfers, a two-car Class 175 train gets underway with its Manchester-bound working. The Maesdu golf club's greens are bisected by the Llandudno Town branch tracks as it approaches the town; the sands behind are the West Shore beach. 28 September 2013.

Freightliner Class 70 No. 70015 sits solo on the up main at Mostyn during engineering operations on 6 January 2013. The dock sidings in view are still in use although they currently have no scheduled traffic. Since the date of this picture, the sidings have been cleared of vegetation and a new connection to the main line laid.

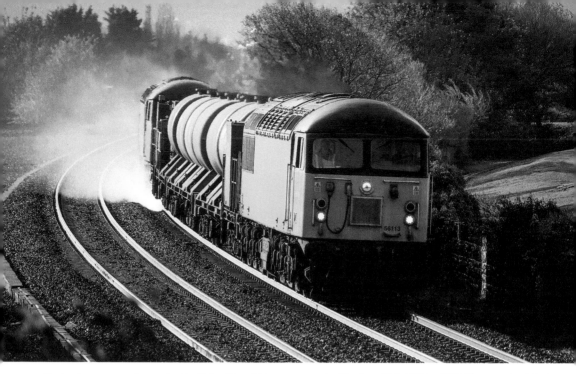

In the first season of operation by Colas Class 56 locomotives, the North and Mid Wales RHTT approaches Rhyl with Nos 56113 and 56087 in charge on 9 November 2016. During its near 20-hour schedule, the train visits seven Welsh and three English counties and covers around 550 miles of track.

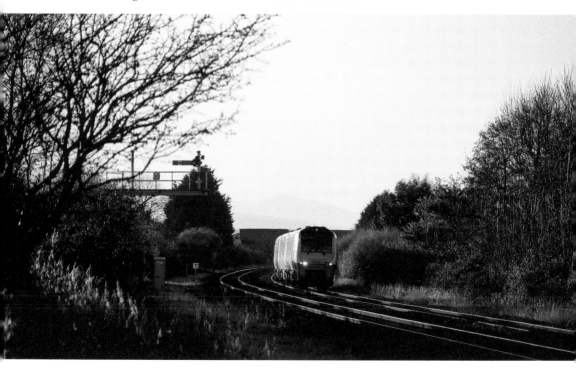

The mid-afternoon sunset surround Class 175 unit No. 175104 as it approaches Prestatyn with 1H90, Llandudno to Manchester Piccadilly, on 28 November 2016. The Class 175 units were the last trains built from scratch at the now closed Metro-Cammell works at Washwood Heath near Birmingham.

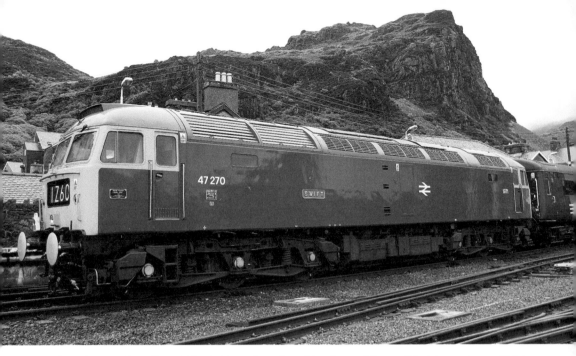

Fresh from the paint shop, Class 47 No. 47270 stands in the stabling loop at Blaenau Ffestiniog station on 10 July 2010. The name *Swift* is not original to the locomotive: Class 43 Warship D850 carried the name until withdrawal in May 1971.

With Class 67 No. 67010 at the rear propelling the train, 1H89 from Holyhead to Manchester Piccadilly enters the cutting before the short tunnel at Rockliffe Hall on 28 November 2016. Situated at the other end of the tunnel, the signalbox at Rockliffe Hall closed in March 2018 after the completion of phase one of the resignalling works.

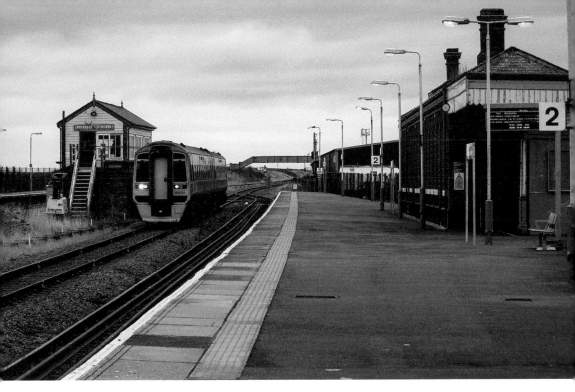

During the final days of use, Class 158 unit No. 158820 passes the down platform loop at Abergele and Pensarn with a Birmingham International to Holyhead run on 3 January 2017. Crudely fashioned from the former down slow line lifted in the late 1980s, the loop was renowned for its slow entry and exit speeds.

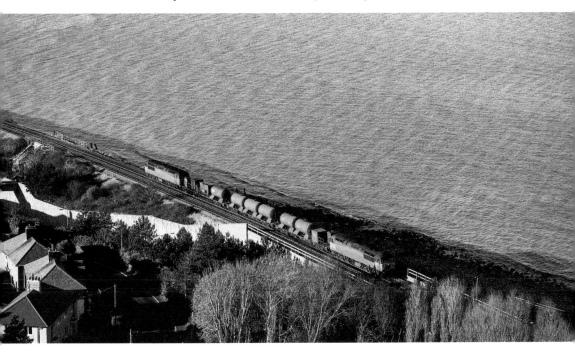

Class 56 locomotives Nos 56087 and 56078 on the sea wall at Old Colwyn with the 3S71 RHTT working on 25 November 2016. The train is on the Tan Lan bridge, which crosses the main A55 expressway, and is climbing up from the sea to Penmaenrhos tunnel before the long, gentle descent to sea level at Pensarn beach.

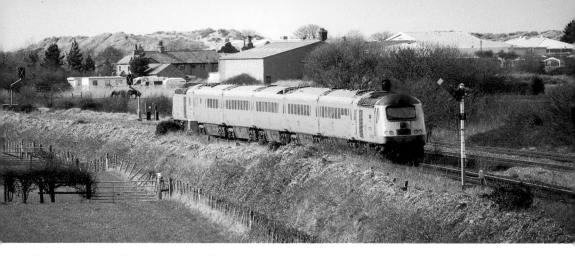

The Network Rail New Measurement Train is scheduled to visit the coast on every fourth Thursday and its afternoon timings make photography easy for much of the year. Only the main line is covered, with an hour's tea break at Holyhead before the return journey. The westbound working passes Talacre on 22 March 2018.

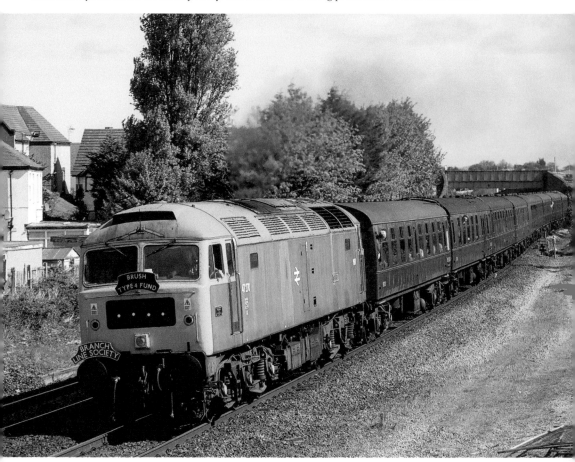

West Coast Railways have provided trains for charter workings in North Wales for some years and their maroon rolling stock has become a familiar sight. It isn't hauled by a blue locomotive quite so often though, so a rather weather-worn Class 47 makes an interesting change. No. 47270 takes power leaving Rhyl down platform loop with a Branch Line Society charter from Carnforth to Holyhead on 22 April 2017.

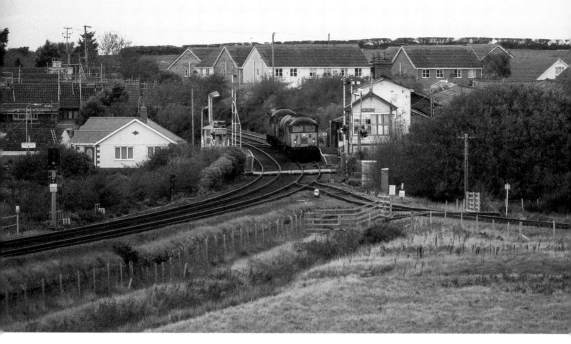

The much-rationalised signalling over the Isle of Anglesey can sometimes lead to delays if trains leave either Bangor or Holyhead in quick succession. With a stopping train in front, the Railhead Treatment Train has been held at Valley station awaiting clearance to proceed to the next section at Gaerwen, 15 miles to the east. On 26 October 2016, this process took 20 minutes.

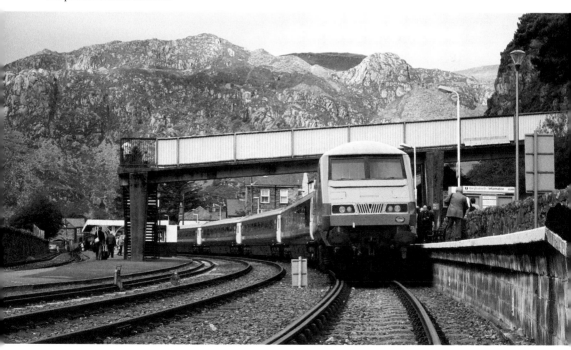

Framed by footbridge and scenery, an Arriva Trains Wales-liveried Mark 3 driving van trailer makes an unusual sight at Blaenau Ffestiniog on 28 September 2013. The Holyhead-based set, including restaurant car, visited with a charter associated with the Community Rail Partnerships conference in Llandudno.

Left: Substituting for an unavailable Colas Rail Class 37, Europhoenix-owned No. 37611 sits on a scheduled break at North Llanrwst with the Network Rail ultrasonic test train on 22 February 2018. During a two-day stay, the train covered the entire North Wales coast and branches.

Below: West Coast Railways Class 47 No. 47804 leads a Grantham to Blaenau Ffestiniog charter through the closed Blaenau Ffestiniog North station on 5 June 2010. Replaced by a new joint British Rail/Ffestiniog Railway station much nearer to the town centre, this station closed in 1983 but the buildings were not demolished for almost another thirty years.

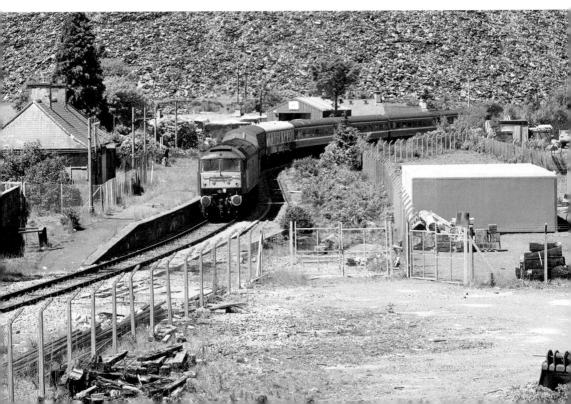

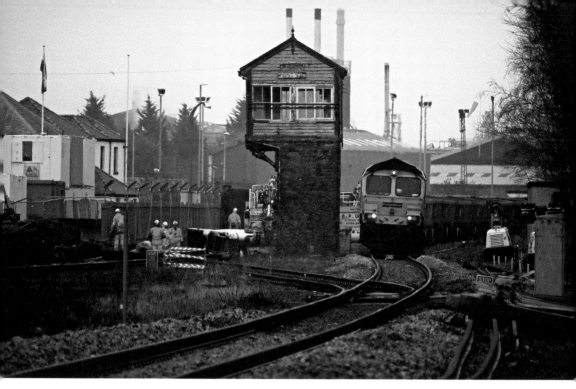

Work commenced on phase one of the North Wales Coast resignalling project in January 2017 at Mostyn. A new bi-directional passing loop was laid, including a new connection into the dock sidings, and parts of the existing layout removed. Freightliner Class 66 No. 66589 presides over the work on 21 January 2017.

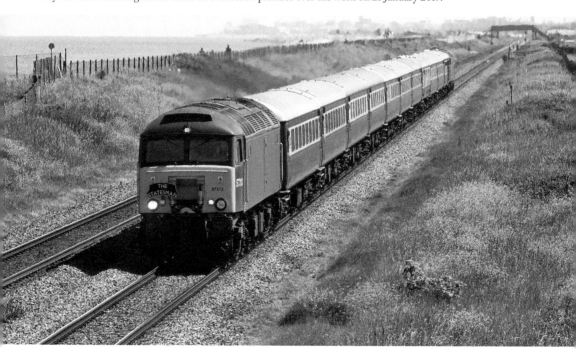

The Statesman Snowdonian charter of 14 June 2014 runs along the coast towards Abergele and Pensarn station with former coast regulars Nos 57313 and 57316 powering the train. The Class 57/3 fleet, owned at the time by Virgin Trains, was a regular sight hauling passenger workings in North Wales until 2013 for both Virgin and Arriva Trains Wales.

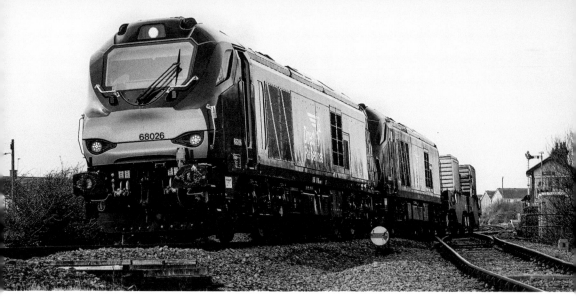

Class 68 locomotives Nos 68026 and 68030 make a spirited start away from Valley with 6K41 nuclear flasks to Crewe on 11 April 2018. The class do not have any current passenger workings in Wales but are finding regular employment with several operators including Arriva Rail Northern, Chiltern Railways, Scotrail and TransPennine Express.

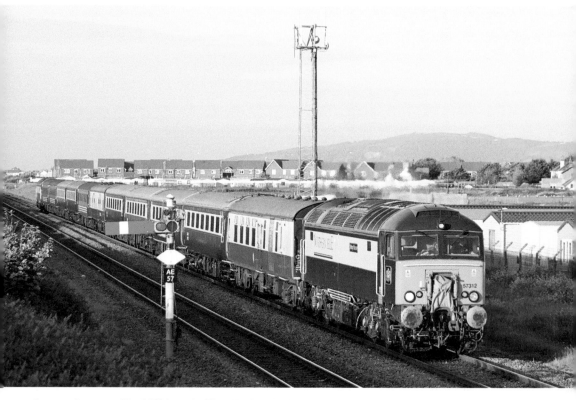

An annual visitor to North Wales is the Three Peaks by Rail charter, a railway industry charity fundraiser that visits the highest peaks of England, Scotland and Wales to enable participants to take part in sponsored climbs on a start to finish time limit of 48 hours from London. In its time it has raised well over £2 million. The ascent of Snowdon is done overnight from Bangor. Seen here on 18 June 2015, the train heads west with Class 57 No. 57312 in charge, its occupants limbering up for the long night ahead.

Freightliner have no scheduled work along the coast, but often provide trains for infrastructure works. On 11 June 2016, Class 66 No. 66554 drops down into Old Colwyn with a short train of spoil wagons destined for a night's work further along the coast.

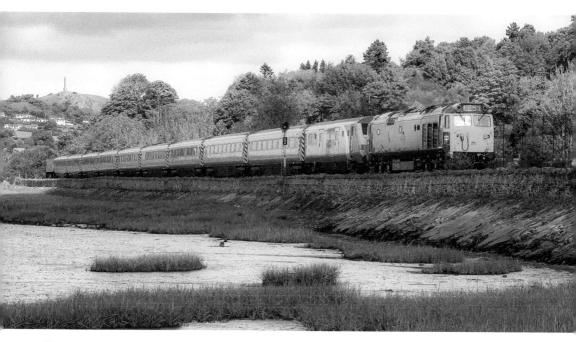

Class 50 locomotives have never been a common sight in North Wales; even during the period from 1967 to 1976 when the locomotives were based at Crewe depot, they only infrequently went west of Chester. The Snowdon Ranger railtour took No. 50044 *Exeter* to Holyhead and North Llanrwst on 4 September 2011; the locomotive leads the Virgin Trains 'Pretendolino' stock along the Conwy Valley line at Glan Conwy, with Class 57 No. 57304 on the rear to return the train to Llandudno Junction.

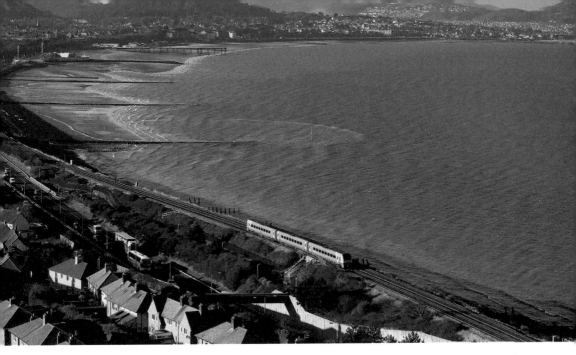

Known locally as the Seventy Degrees, a reference to a long-gone hotel, the cliffs above Colwyn Bay provide a superb view of the railway as it cuts across the bay. On 25 November 2016, a three-car Class 175 unit catches the sun as it rolls west on a working from Manchester Piccadilly to Llandudno.

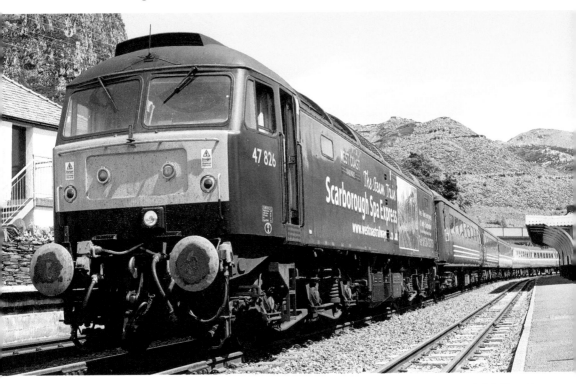

Stabled in the centre road at Blaenau Ffestiniog, West Coast Railways Class 47 No. 47826 acts as a mobile billboard for the company's Scarborough Spa Express operation on 5 June 2010. The loco carried this livery for more than one season, but it was only ever applied to this one side.

Low tide and low light at Mostyn Dock on 6 January 2013 as two Freightliner Class 70 locomotives are involved with the replacement of track on the up line. Freightliner is now owned by the American Genesee & Wyoming Railroad and the Class 70s appear to have fallen from favour; at the time of writing only six of the class remain in active use.

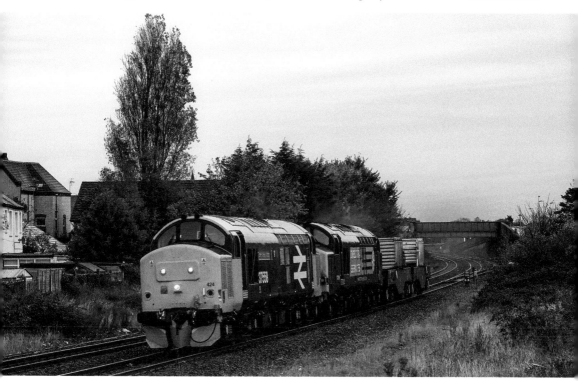

A popular reinstatement to traffic during 2016 was Direct Rail Services-owned Class 37 No. 37424, one of the thirty-one locomotives converted for electric train supply by British Rail during the mid-1980s. The loco currently carries the number 37558 to commemorate its name *Avro Vulcan XH558*, the last Vulcan bomber to remain flying. The loco is running with No. 37259 on 6D43, Crewe to Valley nuclear flasks, at Rhyl on 14 November 2016.

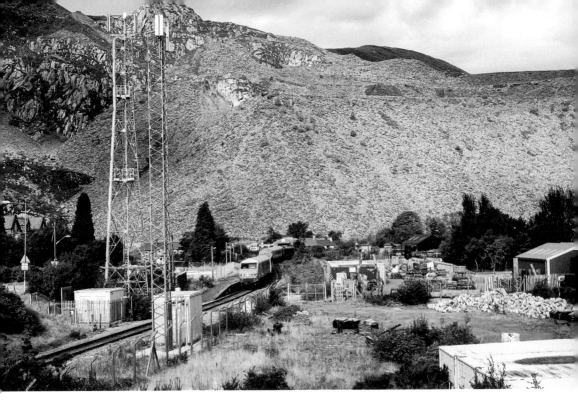

Slate waste towers over the Community Rail Partnership charter at long closed Blaenau Ffestiniog North station on 28 September 2013. The old station building had recently been demolished when this photograph was taken.

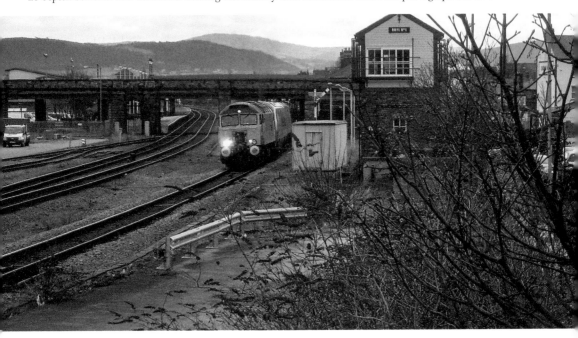

Back in 2010, there was still a once a week regular working for a Class 57 dragging a Class 390 Pendolino unit to Holyhead and back. The working was on a Saturday and was utilised to retain driver knowledge of the method of working trains in this mode. No. 57312 leaves Rhyl with 1A55 Holyhead to Euston on 13 February of that year. The working finished in 2012.

The deserted beach at Colwyn Bay on 9 December 2017 with a three-car Class 175 unit on a Cardiff Central to Holyhead working. Class 175 units currently work around half of the passenger trains along the coast but will be replaced by new CAF Civity units from 2022.

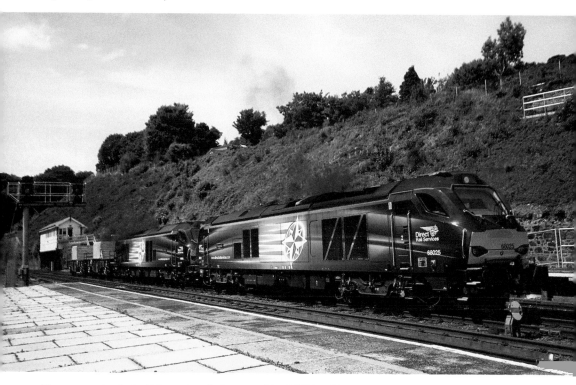

The present-day look of the nuclear flask train in North Wales. Class 68 locomotives Nos 68025 and 68005 lead 6K41, Valley to Crewe, through the now seldom-used centre road at Bangor station on 14 June 2017.

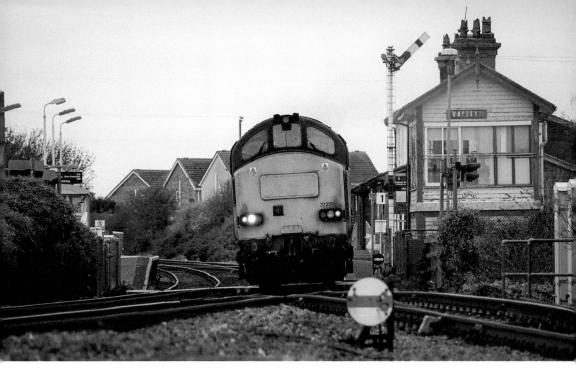

Back when the regular motive power was a pair of Class 37s, Nos 37259 and 37038 make an energetic start with the 6K41 flasks to Crewe. With continuation of the resignalling project indefinitely on hold, the Grade II listed signalbox is likely to continue to signal trains for some time to come. It is seen here on 26 October 2016.

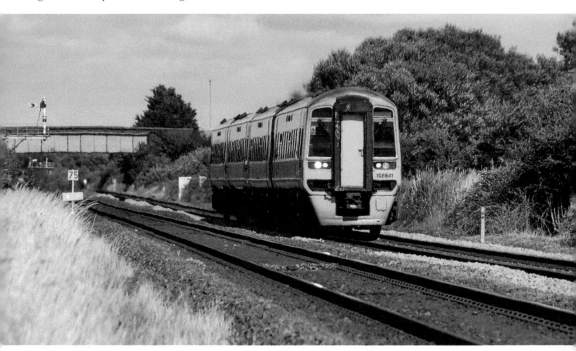

At well over 4 hours, it's a long journey from Holyhead to Birmingham in a Class 158 unit. Nearly all trains from North Wales to the West Midlands operate via Shrewsbury rather than on the traditional route through Crewe. This adds around 45 minutes to the journey time. Bound for Holyhead, 1D14 from Birmingham International approaches Rhyl on 29 July 2015.

Originally ordered by FirstGroup for its North Western franchise, the Class 175 units have been concentrated on the Wales and Borders franchise since 2005 and are maintained at a purpose-built depot near to Chester station. Seen near Talacre, a mid-afternoon Manchester Airport to Llandudno run utilises No. 175107 on 26 March 2018.

Colas Rail Freight-owned Class 60 No. 60002 at Rhyl on 22 January 2017 with a track relaying train. Colas utilised several of their Class 60s on the coast during 2017, bringing the class back to the area after several years of absence.

A busy scene at Blaenau Ffestiniog on 28 September 2013. This station replaced the former North station in 1983 and brought all forms of transport to the town centre. The Network Rail and Ffestiniog Railway stations are self-evident; behind the station is a bus and taxi interchange as well as car parking facilities.

A rather wet Chester station on 21 November 2009 with Class 175 units awaiting departure time with services to Cardiff Central and Holyhead respectively. In recent years, Chester station's role as an interchange point has dramatically increased with the introduction of more frequent services on every route serving the city.

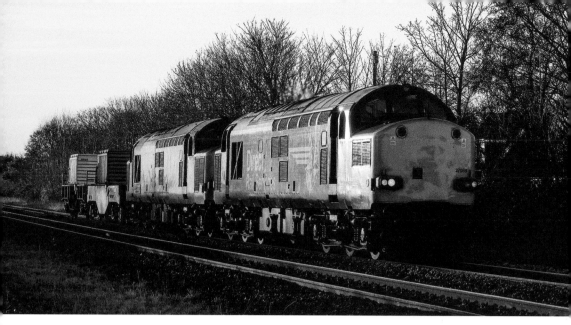

The short winter days can provide some glorious sunsets to accompany the eastbound nuclear flasks. On 28 November 2016, everything fell perfectly into place: a pair of Class 37s, timely running and the perfect setting sun. Passing Prestatyn, Nos 37059 and 37610 head for Crewe with 6K41 from Valley.

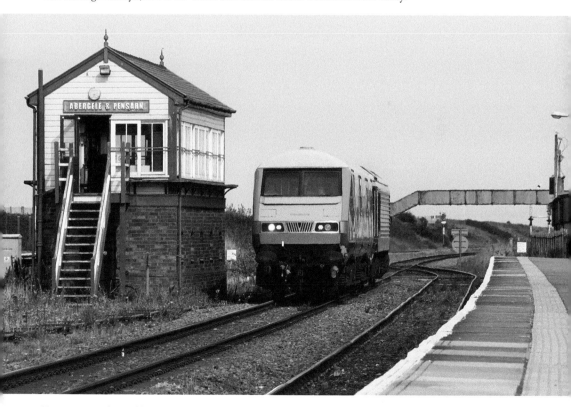

During 2012, Arriva Trains Wales sourced Mark 3 coaches to replace their existing Mark 2 stock. The decision to adopt push-pull working was also taken and driver training commenced during the summer with Class 67 locomotives hired in from DB Cargo and Mark 3 driving van trailers. DVT No. 82307 leads No. 67001 on one of the training runs at Abergele and Pensarn on 3 September 2012.

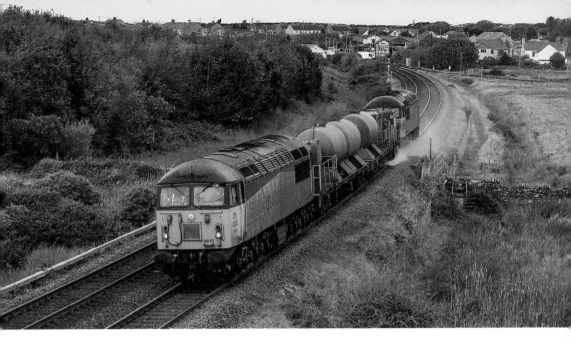

With autumn's leaf-fall in full swing, Nos 56113 and 56087 get to grips with 3S71, the North and Mid-Wales Railhead Treatment Train, at Valley on 26 October 2016. The train appears to be short formed; six tanks are more normally used along the coast.

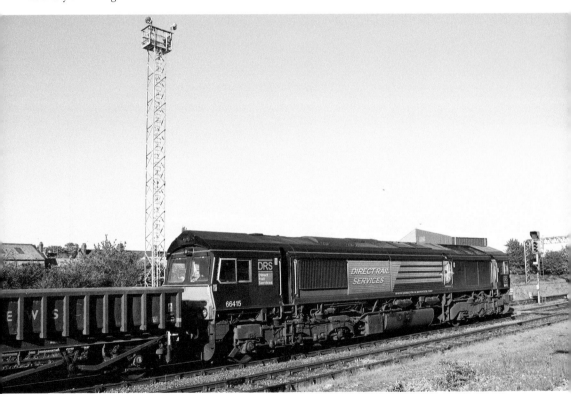

On 25 May 2013, Class 66 No. 66415 is stabled in the east yard at Chester station with an engineers' spoil train from Bache, first stop on the Merseyrail Wirral line to Liverpool. Direct Rail Services Class 66s are now unusual in the area; their more typical use is on long intermodal runs on the West Coast Main Line.

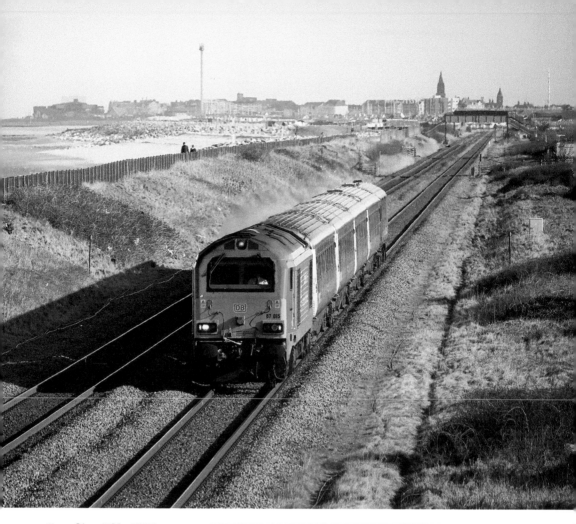

Above: Class 67 No. 67015 races along the sea-level stretch of track at Pensarn beach with 1D34, Manchester Piccadilly to Holyhead, on 7 February 2018. Some 4 miles distant, the town of Rhyl fills the background.

Right: DB Schenker Class 66 No. 66168 stands in Platform 3 of Llandudno Town station at the front of stock that will later form a return charter to London Euston. At the time, it was very unusual to see a locomotive-hauled train at Llandudno. Taken with permission on 3 May 2010.

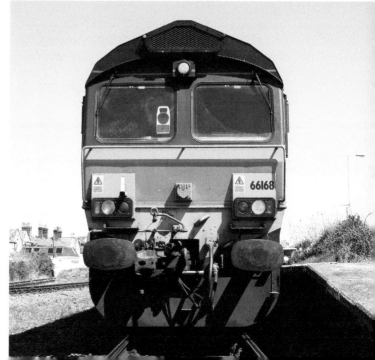

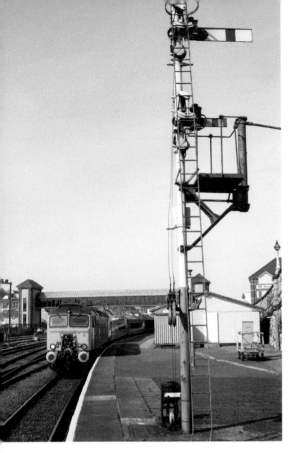

Left: On 24 March 2012, Class 57 No. 57309 stands in Platform 3 of Holyhead station, waiting to haul No. 390047 to Crewe on 1A55 to London Euston. On arrival at Crewe, the Class 57 detaches and leaves the Pendolino to run on electric power for the remainder of the journey. This was one of the last times that the Pendolino drag occurred.

Below: For many years, Penmaenmawr quarry provided ballast to the railway. This ended after the completion of the Manchester Metrolink Oldham loop conversion project. The sidings remain connected to the national network in hope of new traffic. Back on 10 June 2010, Freightliner Class 70 No. 70002 loads a train of box hoppers destined for Guide Bridge.

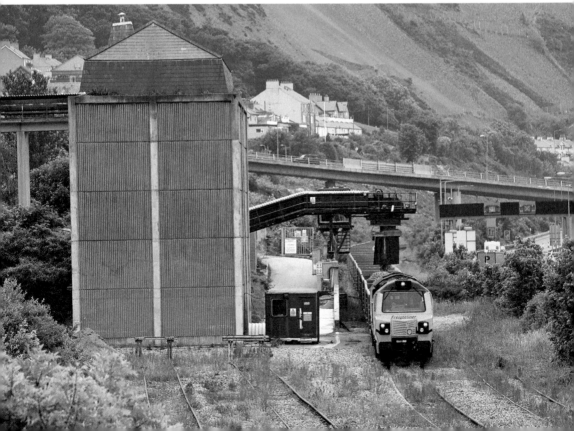

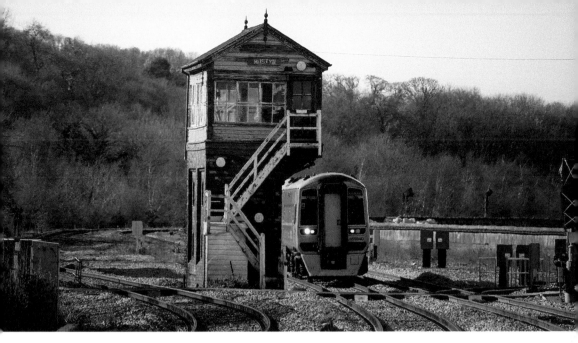

The London & North Western Railway signalbox at Mostyn on 20 March 2018 with Class 158 unit No. 158840 passing on 1G50, the Holyhead to Birmingham International service. The signalbox was closed in early 2017 in advance of the resignalling of the area but remains in situ and was repainted during April 2018.

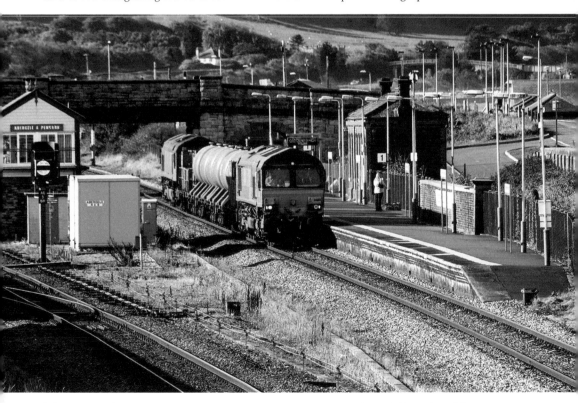

DB Schenker Class 66 No. 66101 leads the railhead treatment train through Abergele and Pensarn station on 24 October 2010. Class 66s from the DB fleet have never been very common on the coast and currently the only trains they lead through North Wales are charter trains or railtours.

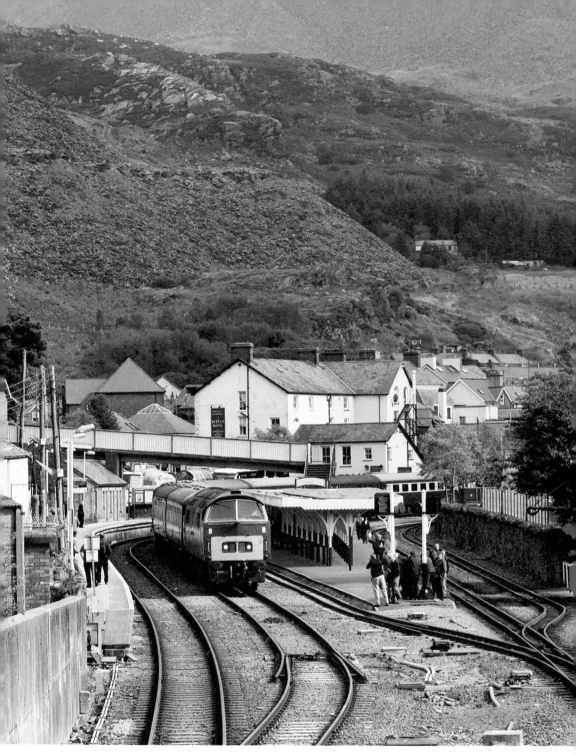

Currently the only main-line certified diesel-hydraulic locomotive, the Diesel Traction Group's Western Class 52 D1015 *Western Champion* rests at Blaenau Ffestiniog after bringing the Western Slater railtour to the town from Didcot Parkway on 19 September 2009. During the very early life of the class, they were a regular sight at Chester on trains from Paddington; the passing of the line from Western Region to London Midland Region control in 1963 led to their replacement by Brush Type 4s.

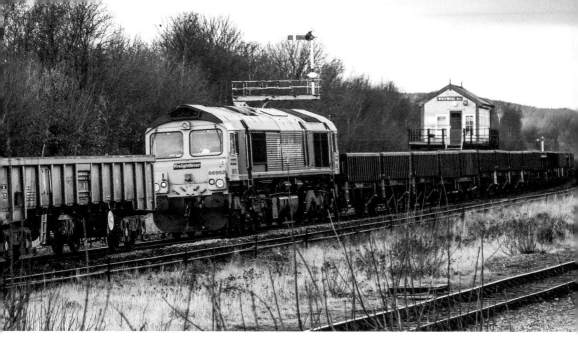

Freightliner Class 66 No. 66952 waits the call to duty with a train of wagons for spoil. The down line through Holywell Junction was being relayed when the picture was taken on 6 January 2013. At the time, the loops at the location were still in use.

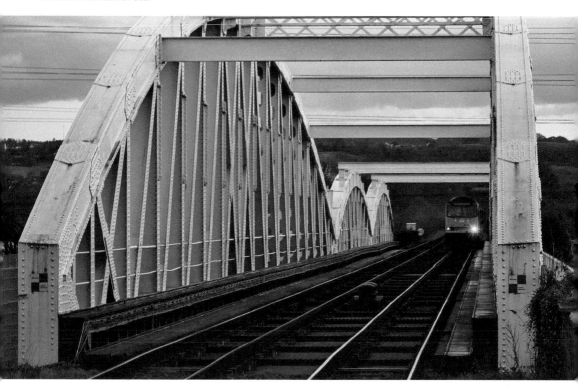

The last main-line diesel locomotive to be built in Britain, No. 60100, approaches the Dee bridge just yards from journey's end at Dee Marsh with 6M30, the steel service from Margam. Class 60 locomotives were frequent performers on these workings until they passed from DB Cargo to Freightliner a couple of months after this scene was recorded on 2 April 2017.

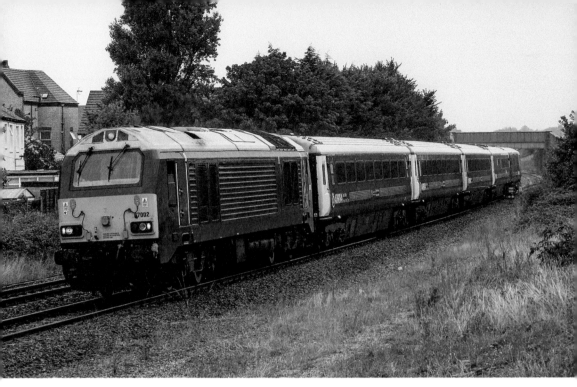

The comparatively rare sight of a full blue set on the WAG Express. Arriva-liveried No. 67002 leads 1W96, Cardiff Central to Holyhead, away from Rhyl on 3 September 2016. Substitution of the blue locomotives by EWS or DB Cargo-liveried locos has become very common, to the point that the blue locos are rarely seen in Wales.

Contrasting motive power at Bangor on 14 June 2017. Left is Colas Rail Class 37 No. 37254, stabled with a Network Rail test train that will run later in the evening to Derby. To the right, the more normal sight of an Arriva Trains Wales Class 158 operating 1D13 from Birmingham International to Holyhead.

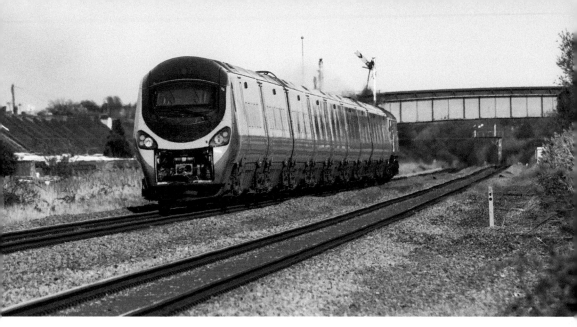

A Pendolino unit being dragged east towards Prestatyn by a Virgin Trains Class 57 on 9 April 2011. When this method of operation was used along the coast, the train required two drivers: one to drive the Class 57 locomotive as it would be driven on any working, while the second driver rode inside the leading cab of the Pendolino unit to monitor the complex on-train computer system of the Class 390 to ensure all was well.

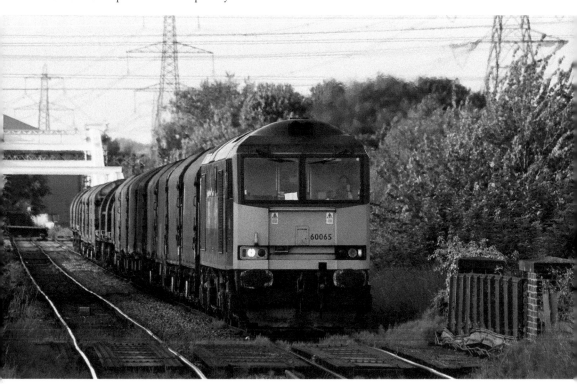

EWS-liveried Class 60 No. 60065 *Spirit of Jaguar* leads the evening 6V80, steel empties from Dee Marsh to Margam, into Shotton High Level station on 19 June 2014. The train is about to cross the bridge spanning the North Wales Coast line; Shotton Low Level station is to the left and reopened to passengers in 1973 after being closed in 1966.

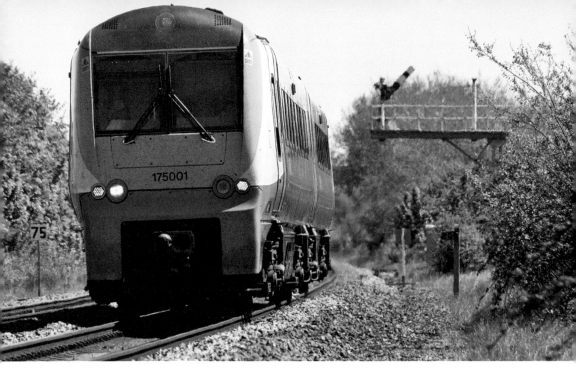

First of its class, No. 175001 leaves Prestatyn with a Llandudno working on 25 May 2013. The Class 175s are the only example of the Alstom Coradia units built for UK service; they total seventy individual cars, formed as eleven two-car and sixteen three-car trains.

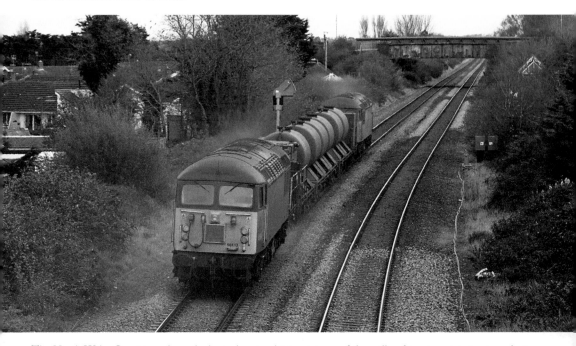

The North Wales Coast is perhaps the best place to obtain pictures of the railhead treatment train at work; its schedule brings it to the line from around 0930 to 1400 six days a week from early October until early December, virtually guaranteeing good daytime light, and the Colas Rail Class 56s are popular with the area's photographers. On 8 November 2017, Nos 56105 and 56113 pass the new signals for Rhyl East Junction on their way back to Shrewsbury Coleham depot.

To some of the locals, the drop down into Shotton High Level heading north on the Borderlands line is called the 'ski slope'. The name was rather appropriate on 25 March 2013 as late winter snow greeted No. 60010 as the locomotive got to grips with 6V75, the Dee Marsh to Margam steel empties. The platforms of the next station north, Hawarden Bridge, can be seen through the bridge girders.

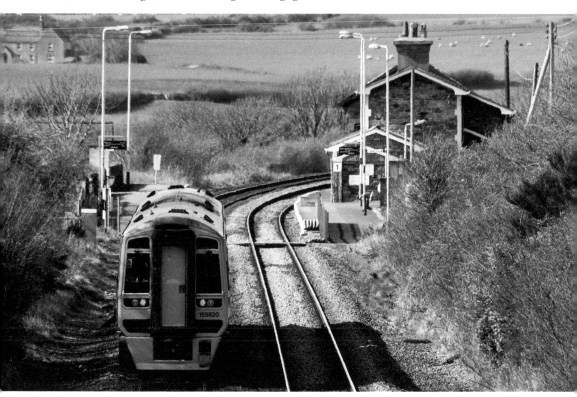

Working 1D12 from Birmingham International to Holyhead, No. 158820 calls at Bodorgan on 24 March 2012. The Anglesey halts have been served by main-line trains in recent years after the withdrawal of the local service to save a unit for use elsewhere. This adds about 15 minutes to the journey.

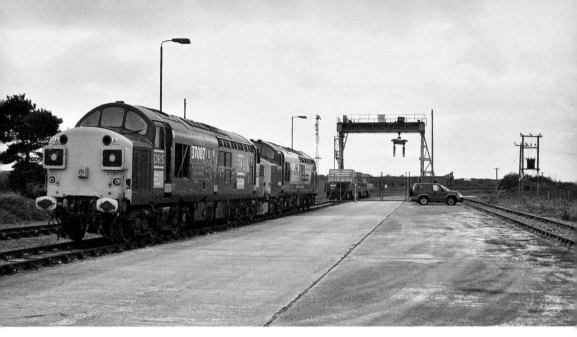

A scene from history now as Class 37s no longer feature on the nuclear flasks, but back on 5 November 2009 it was business as usual with Nos 37087 and 37688 waiting to power 6K41 to Crewe from Valley nuclear terminal.

A comparison of multiple unit and multipurpose vehicle at Chester. The Class 175 is on standby duty, the MPV in use on a railhead treatment train on a wet 21 November 2009.

A late winter sunrise greets a Class 67 at Sandycroft on 2 February 2013. The train was a relief service to Cardiff in connection with rugby at the Millennium Stadium.

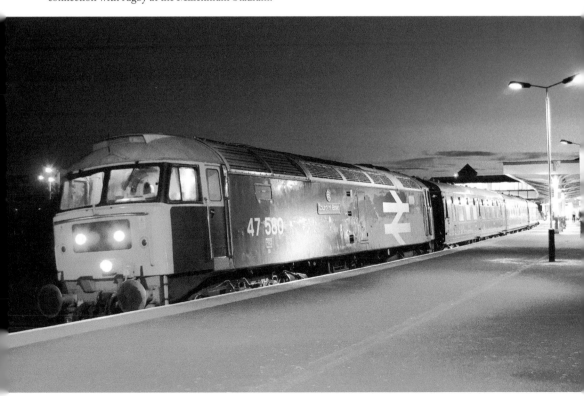

Working for West Coast Railways, Class 47 No. 47580 stands at Llandudno Junction with empty stock for Carnforth on 23 July 2011. The locomotive is privately owned by the Stratford Class 47 Group.

Late evening shadow meets 1V96, Cardiff to Holyhead, as it runs into Bangor station on 1 July 2015. Despite being only just after 9 p.m., the last eastbound service of the day has gone but the procession of westbound trains will continue into the small hours.

Working from Manchester Airport to Llandudno, Class 175 No. 175106 passes the site of the Point of Ayr colliery on 22 March 2018. The recently announced plans for the new Welsh franchise will see the Class 175 trains leave the fleet by 2024.

Class 20s Nos 20189 and 20142 at Llandudno on a charter for GB Railfreight staff on 27 July 2013. Class 20s were regular performers on holiday trains to the town from the East Midlands during the 1980s and 1990s but hadn't visited the town for some years prior to this occasion.

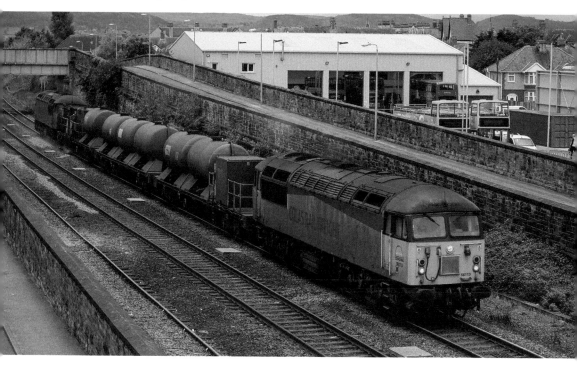

Passing the Arriva bus garage in Rhyl, railhead train 3S71 is powered by the rather grimy No. 56113 and No. 56087 on 3 November 2016. The dirt accumulation on the locomotives is caused by the spray released by the rail treatment process.

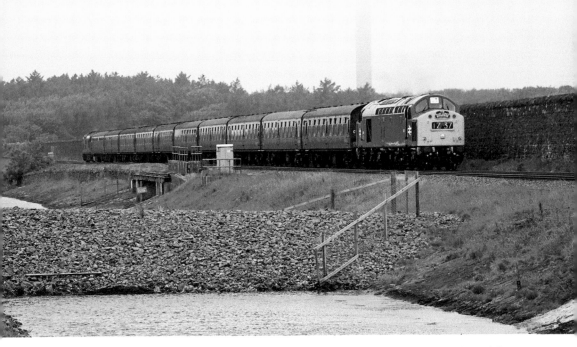

A Class 40 dragging a long train of Mark 1 stock away from Holyhead was a familiar sight and sound for over twenty-five years. History is recreated on 10 June 2017 with D345 (No. 40145) heading across the Stanley Embankment with a charter to Llandudno.

Low tide at the Clwyd Estuary as Direct Rail Services-owned Class 37s Nos 37259 and 37604 head to Crewe with the 6K41 flasks on 24 October 2016. The load carried varies with each train but is a maximum of three flasks.

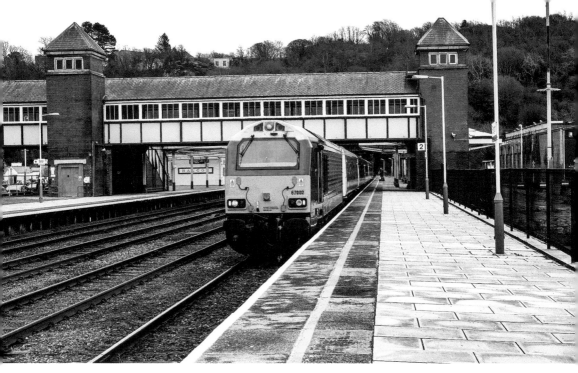

When not on its regular duty, the Holyhead-based hauled set is sometimes used for additional workings. An Easter Monday relief working from Crewe to Holyhead utilised the set on 1 April 2013, seen at Bangor with blue-liveried No. 67002 in charge.

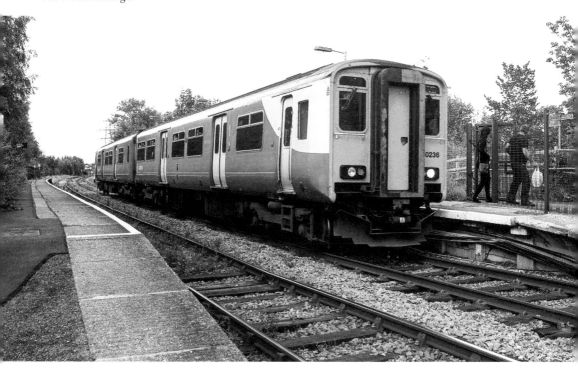

Hawarden Bridge station, on the eastern bank of the River Dee, is located next to Shotton steel works and is served by only a few trains each day. Two passengers alight from the regular Class 150 unit on a Bidston to Wrexham service on 20 July 2012.

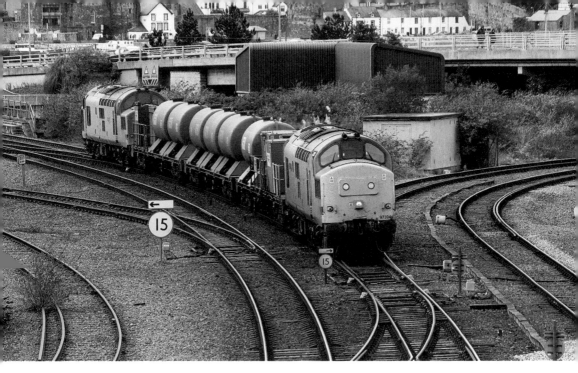

The yellow Network Rail-owned Class 97s saw several years of use along the coast on the railhead treatment train. Currently, they are only used on the Cambrian part of the itinerary, but on 7 October 2011, they would have done the full circuit. Nos 97304 and 97302 arrive at Llandudno Junction heading east.

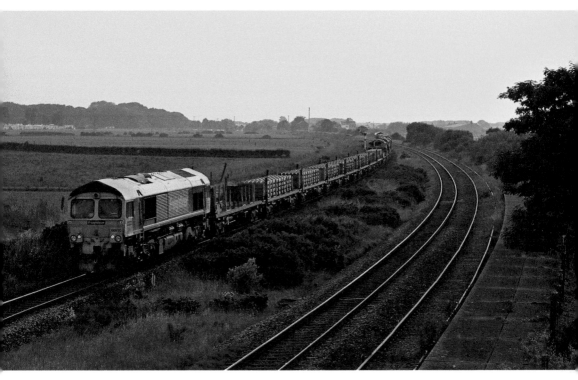

The high output track renewal train powers into the sunset at Talacre with Freightliner Class 66 locomotives on either end. On this occasion, 8 June 2016, the train reversed at Rhyl and returned to Talacre for its night's work.

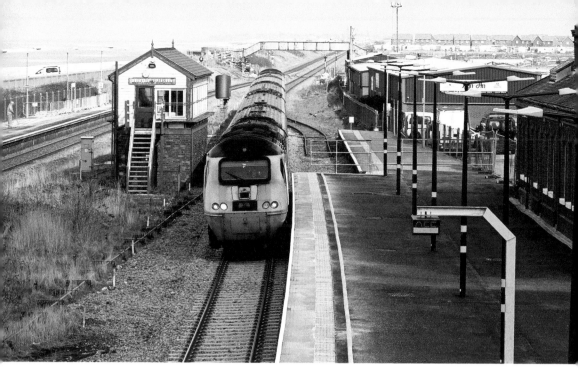

With evidence of the old layout still clearly visible, the New Measurement Train passes Abergele and Pensarn on 23 March 2017. This picture was taken shortly after the station had reopened to traffic following track and platform alterations.

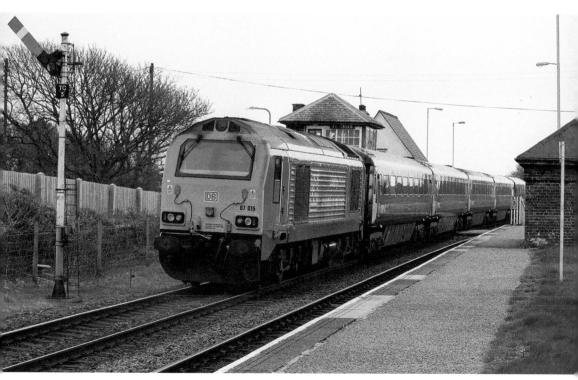

The original CHR signalbox at Ty Croes is one of the oldest surviving boxes in use on Network Rail and dates from the 1870s. No. 67015 passes on 11 April 2018 while pushing 1H89, Holyhead to Manchester Piccadilly, east.

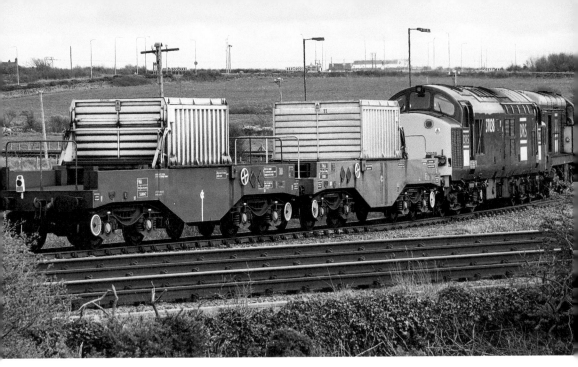

A mixed English Electric duo on the flasks at Valley. Class 37 and Class 20 combinations happened occasionally, and 14 April 2011 sees Nos 37038 and 20303 pushing two flasks out onto the main line before returning to Crewe.

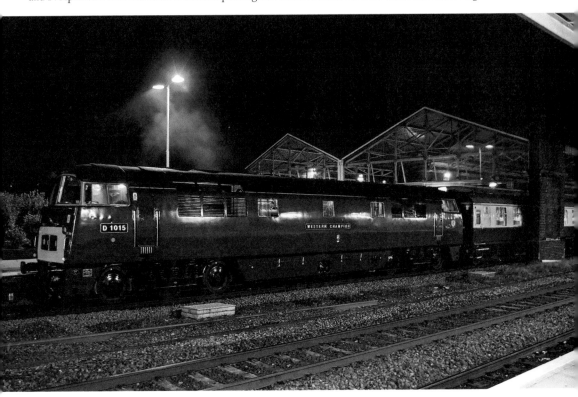

A night-time study of Class 52 D1015 *Western Champion* at Chester on 7 September 2014. The locomotive had just arrived with a GB Railfreight staff charter from the West Somerset Railway at Minehead.

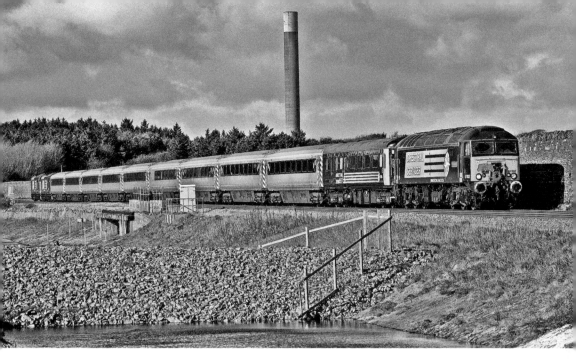

Crossing the Stanley Embankment from Holy Isle to Anglesey, the Welsh Warrior railtour of 25 October 2014 was the official Virgin Trains farewell to the last set of locomotive-hauled stock utilised by the company. Direct Rail Services provided the motive power, with Nos 57302, 37419 and 37682 being utilised.

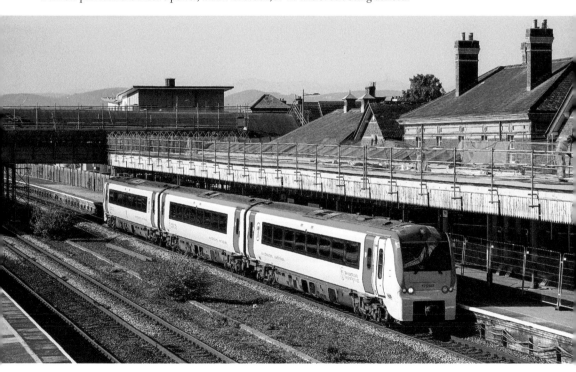

On 14 October 2018, the new Wales and Borders franchise began life operated by Keolis Amey on behalf of Transport for Wales, replacing Arriva Trains Wales, who had operated for fifteen years. The first train to carry the new franchise livery was a three-car Class 175 unit, No. 175107. The unit is seen at Rhyl on 10 October 2018 working from Llandudno to Manchester Airport.

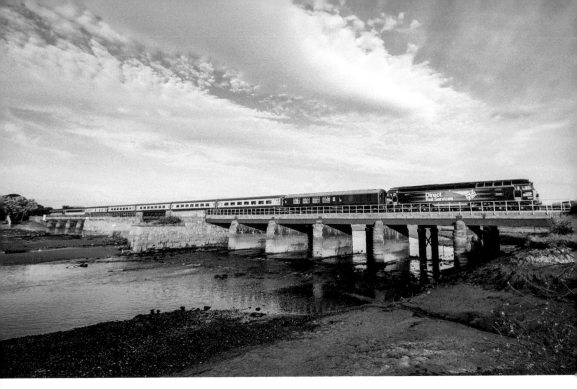

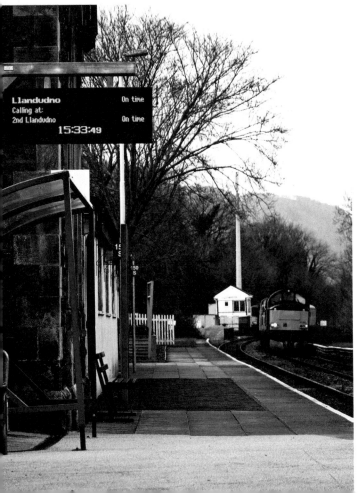

Llandudno On time
Calling at:
2nd Llandudno On time
 15:33:49

Above: A warm summer evening
sees Class 57 No. 57301 leading the
annual Three Peaks by Rail challenge
train through Rhyl on 23 June 2016.
A night-time ascent of Snowdon
looms ever closer for those onboard.

Left: Passing trains at North Llanrwst
on 22 February 2018. The branch
line Class 150 disappears behind the
ultrasonic test train, which had a
scheduled wait of around 45 minutes.
Class 37 No. 37611 gets ready to
proceed south to Blaenau Ffestiniog.

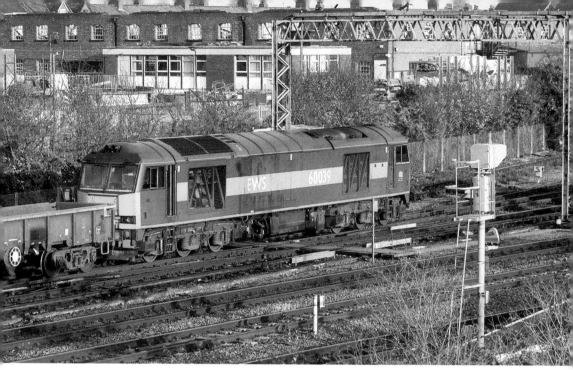

Above: At the time a rare sight, EWS-liveried 'Tug' No. 60039 coasts toward Chester station with an engineers' train from Bache returning to Crewe Basford Hall on 13 November 2011. The locomotive has now been overhauled and currently carries the red DB Schenker livery.

Right: The late evening 1G76 service from Holyhead to Birmingham leaves Rhyl on 30 March 2018, operated by Class 158 unit No. 158829. The Welsh Class 158 fleet is maintained at Machynlleth depot on the Cambrian main line.

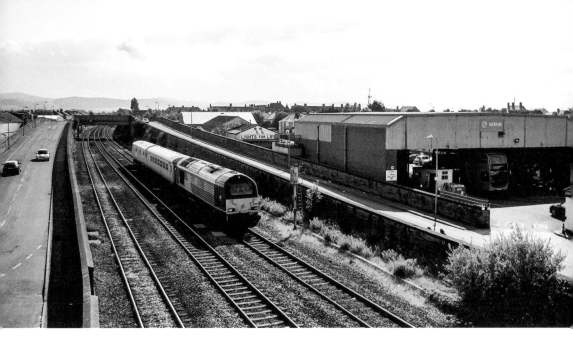

On 8 July 2015, EWS-liveried No. 67008 passes the old Arriva garage at Rhyl while working the plain line pattern recognition train. The garage has now been replaced by a new purpose-built workshop building, as seen on page 51.

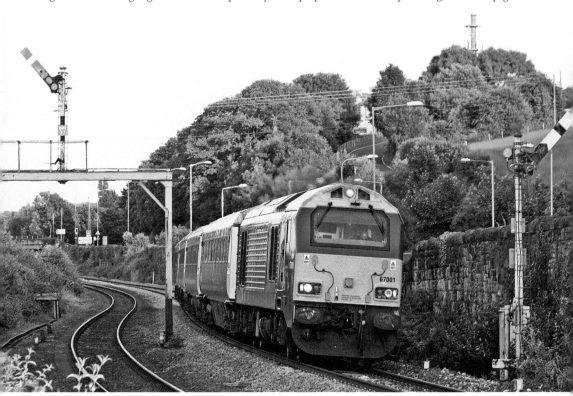

Framed by semaphores at Mostyn, 1W96 from Cardiff Central to Holyhead travels west powered by blue-liveried No. 67001 on 19 June 2014. In practise, the three blue Class 67 locomotives are the least likely of the class to be used on the loco-hauled trains.

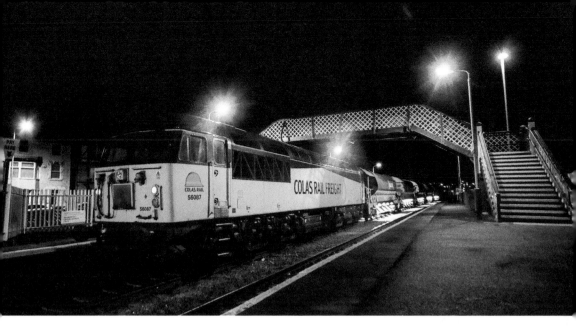

In the last minutes of 24 April 2018, Colas Class 56 No. 56087 stands in Deganwy station at the rear of an auto-ballaster set during a ballast drop on the Llandudno branch. The branch closes overnight and any train here after 10 p.m. is an unusual sight.

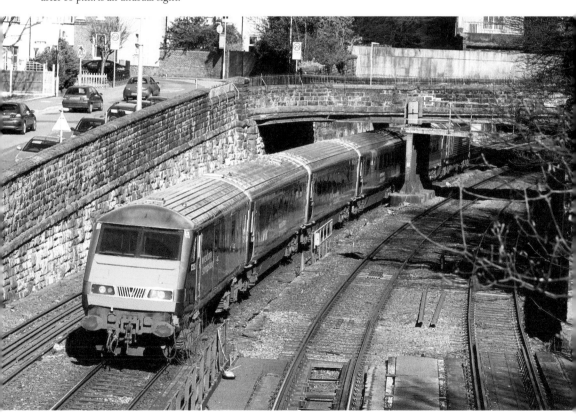

On a Sunday morning diversion, a Wrexham & Shropshire service from Wrexham General to London Marylebone passes Northgate Locks to the west of Chester city centre with hired-in No. 67010 leading the train. Sadly, Wrexham & Shropshire ceased trading early in 2011.

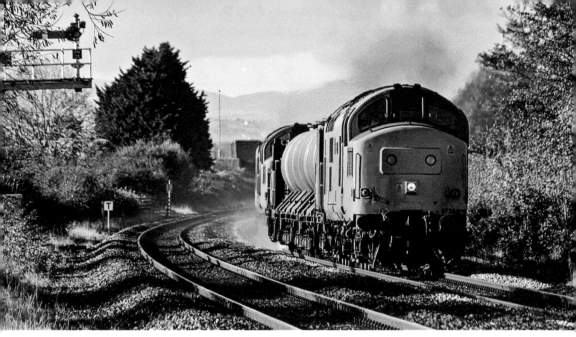

Above: A powerful study of Network Rail's Nos 97304 and 97302 at Prestatyn on 9 November 2013 while working the 3S71 railhead treatment train. The four NR Class 37s are standard Class 37s that have been renumbered into the departmental series; they were formerly Nos 37100, 37170, 37178 and 37217 respectively.

Left: Colas Rail Freight have been extensively involved with the North Wales Coast route modernisation, mainly using their Class 56 and 60 locomotives. On 21 January 2017, No. 56113 sits at Mostyn with a train of concrete sleepers, which were utilised in the creation of a new passing loop and junction.

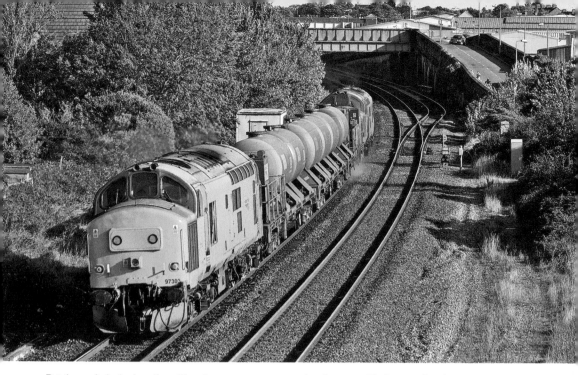

Bright sunlight bathes the railhead treatment train as it heads east at Rhyl on 18 October 2014. Network Rail Class 37s Nos 97304 and 97303 power the train. The leaves on the trees are beginning to turn, a sure sign that the train will be needed for some weeks to come.

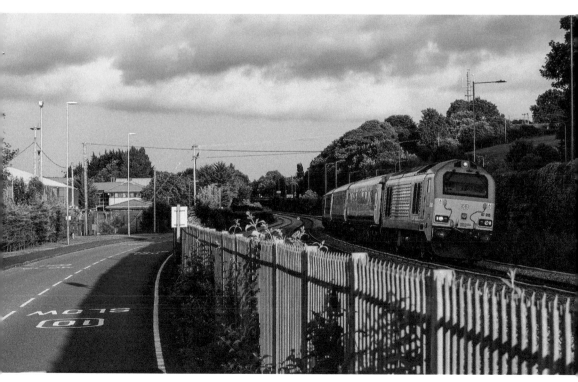

Seen at Mostyn, 1W96 from Cardiff Central to Holyhead heads into the sun on 12 June 2018. DB Cargo-liveried No. 67015, unusually, is in the lead; the loco is normally at the rear of this service along the coast.

The glow from the bright new LED signals gives the front of Class 66 No. 66511 a red hue as it waits with an engineering train. Seen at Rhyl on 14 April 2018, the train would later assist in pointwork removal at Talacre.

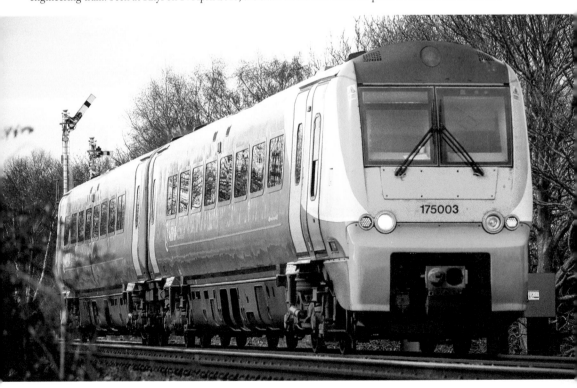

Class 175 unit No. 175003 rushes past the semaphores of Holywell Junction on 20 March 2018 while working 1V96, the Holyhead to Maesteg service. Although booked as a three-car unit, on this occasion a two-car set has substituted.

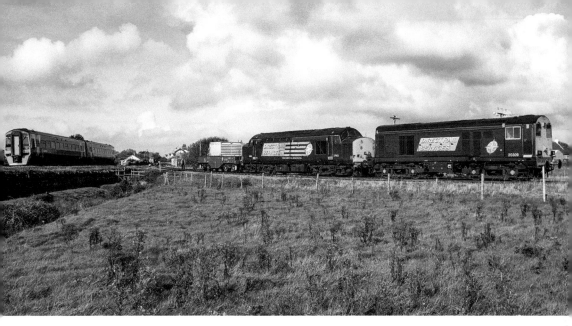

A Class 158 unit drifts west as Nos 20309 and 37603 are readied to reverse out of the Valley triangle with 6K41, the flasks to Crewe, on 13 October 2011. The train has for some years been scheduled out just before 3 p.m. but frequently runs up to an hour early.

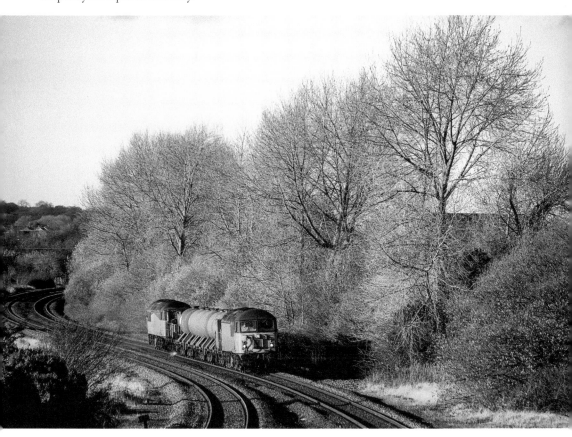

Low golden sun, bare trees and dirty locomotives are all tell-tale signs that the railhead train's season is at an end. The end of the first year of Class 56 power is near as Nos 56087 and 56078 pass Bagillt on 28 November 2016.

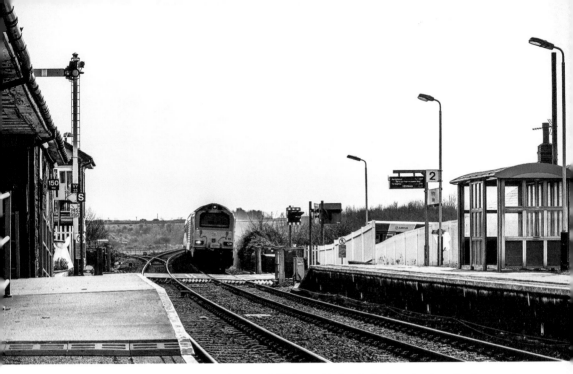

Locomotive-hauled daytime trains returned to North Wales in 2015 with the introduction of a diagram that included a mid-morning Manchester to Holyhead run that returned early afternoon, then a peak hour Manchester to Llandudno service, with an evening return to Crewe. At Valley on 11 April 2018, Class 67 No. 67015 is just a couple of miles away from its Holyhead destination.

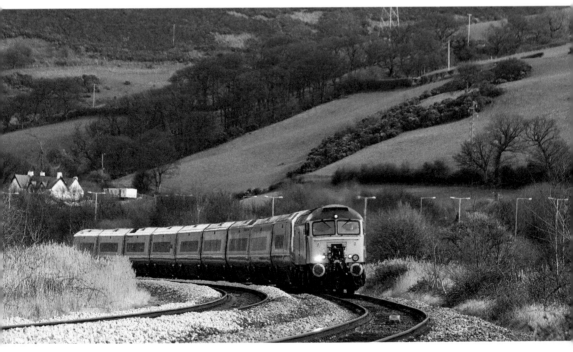

On 17 March 2012, No. 57309 leads the morning Euston to Holyhead service through the valley between Colwyn Bay and Llandudno Junction. Soon after, Virgin Trains sold its Class 57 locomotives; the sixteen-strong fleet was split by Direct Rail Services, West Coast Railways and Network Rail.

Twenty-five years of railway design separate the Class 56 locomotive, first introduced in 1976, and the Class 221 Voyager multiple unit from 2001. The roots of the Class 56 design lie much deeper, however, as its ancestry can be traced right back to the prototype designs from the late 1950s. Nos 56105 and 221118 share the stage at Llandudno Junction on 23 April 2018.

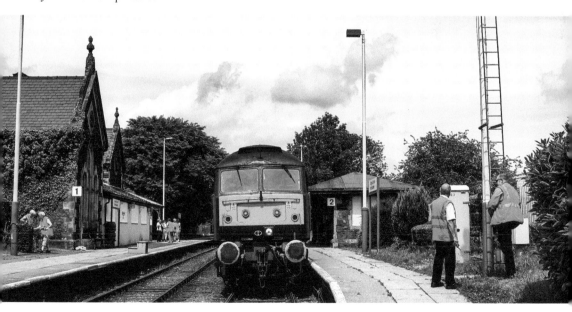

Taking a quick break while waiting for the branch train to clear the section ahead, a West Coast Railways charter headed by Class 47 No. 47804 stands at North Llanrwst on 5 June 2010. The station seems to be in the process of a late spring clean.

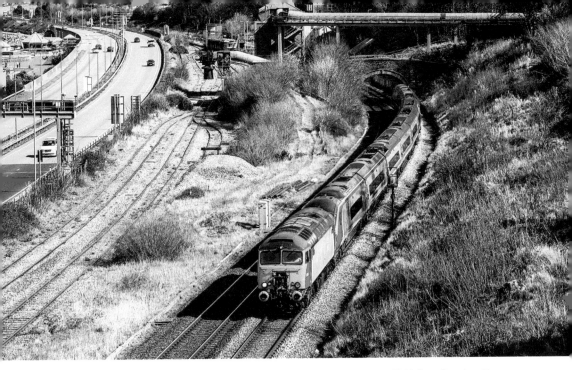

Just a few weeks before the final scheduled Pendolino working along the coast, 1D83 from London Euston to Holyhead threads past the quarry sidings at Penmaenmawr, Class 57 No. 57309 leading unit No. 390047, on 24 March 2012. All Virgin services on the coast are now worked by Class 221 Voyagers.

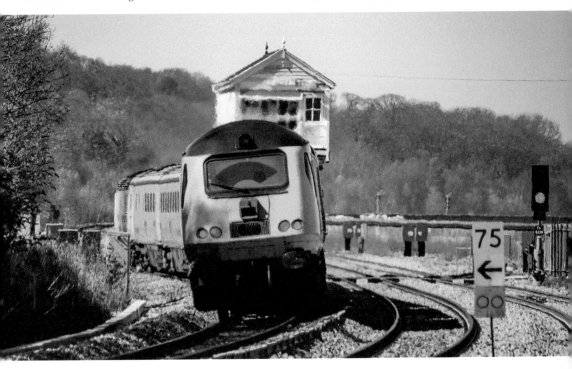

The new measurement train HST passes Mostyn signalbox on its scheduled four-weekly trip along the coast. Despite being closed for over a year, on 19 April 2018 the Grade II listed box was in the middle of a repaint, its first in thirty years.

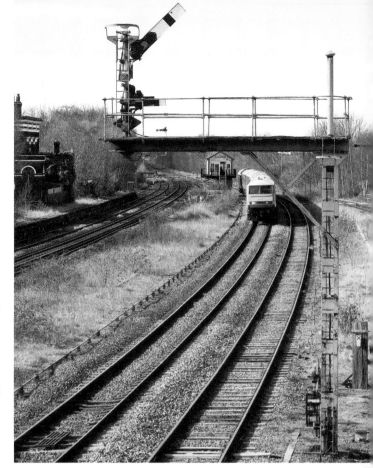

Right: A look at Holywell Junction just six days before closure of the loops and signalbox. Taken on 20 March 2018, the loco-hauled 1H89 Holyhead to Manchester Piccadilly service passes the box with DVT No. 82307 leading.

Below: On 22 February 2018, hired-in Europhoenix Class 37 No. 37611 stands in for a Colas Rail locomotive on an ultrasonic test train working at Blaenau Ffestiniog. Until 2017, the locomotive was owned by Direct Rail Services, who sold some of the fleet after delivery of new Class 68 locomotives.

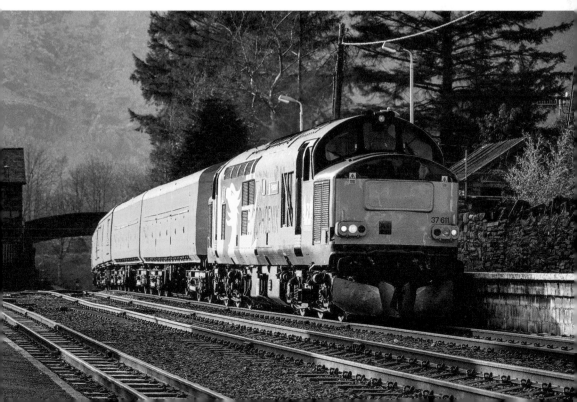

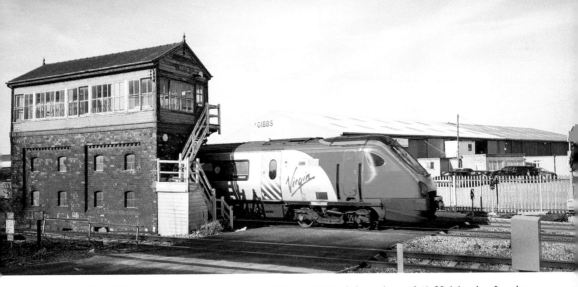

Voyager unit No. 221109 passes Mostyn signalbox on 20 March 2018 while working 1A48, Holyhead to London Euston. The narrow cantilevered LNWR signalbox was retained after the 1980s rationalisation to allow access to Mostyn Dock sidings.

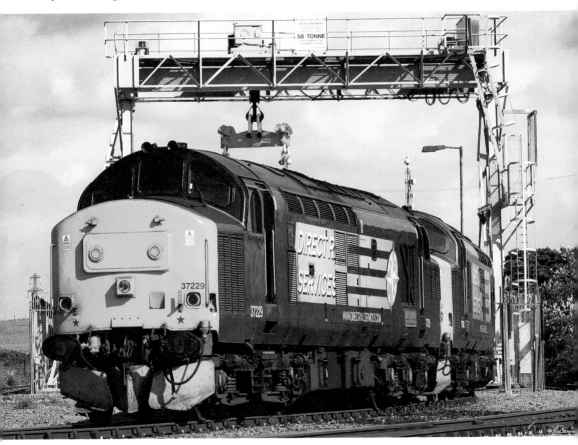

Classic traction at Valley. While in theory any of the DRS locomotive fleet could turn up, the Valley flasks were dominated by Class 37 haulage up until the Class 68 takeover in 2017. Nos 37229 and 37682 await their cargo on 22 September 2011.

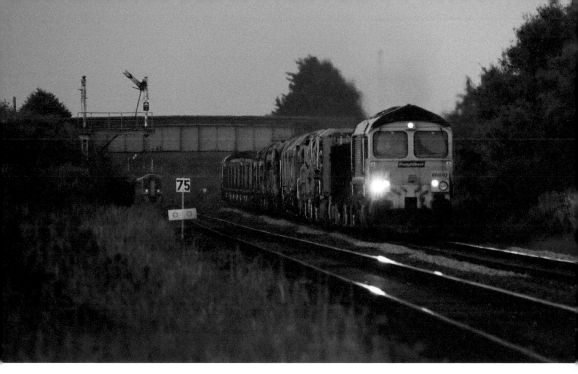

Semaphore distant signals on main lines are now a rarity; this one, sadly, is no longer still in use, a casualty of the 2018 resignalling scheme. Freightliner Class 66 No. 66610 on engineers' duty passes Prestatyn's up distant on 6 June 2016, heading for Talacre after reversal at Rhyl.

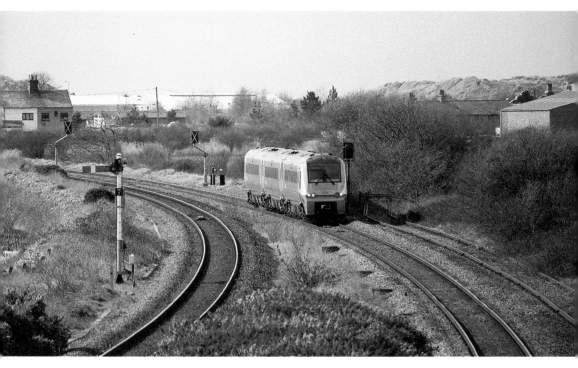

Three generations of signalling surround Class 175 unit No. 175105 at Talacre on 22 March 2018. Just a few days after, the British Rail-era semaphore and colour light signals gave way to the latest generation modular, computer-controlled LED signals behind the train.

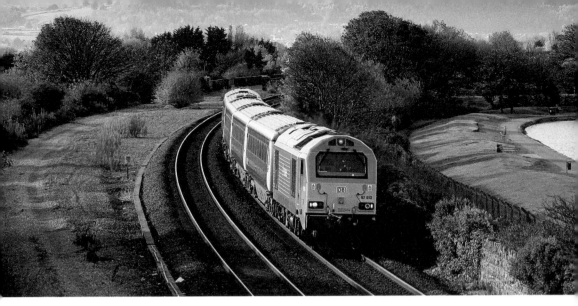

The Holyhead-based locomotive-hauled Mark 3 set at Rhyl on 1V41, Holyhead to Cardiff Central, with DB Cargo-owned No. 67013 powering the train. The Mark 3 coaches are due to be replaced in late 2019 with Mark 4 stock cascaded from the East Coast Main Line.

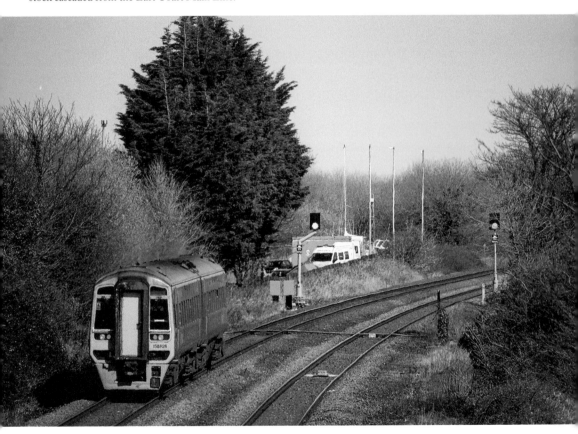

Approaching new signals, Class 158 unit No. 158826 heads east from Prestatyn while forming 1G40, Holyhead to Birmingham International, on 5 April 2018. The 158s, part of the scene for nearly thirty years, are due to be replaced by new CAF Civity units by 2023.

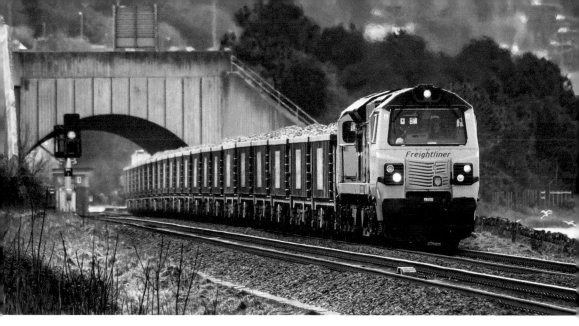

Less than two years old at the time, freightliner Class 70 No. 70004 leaves Penmaenmawr Quarry with the 6H45 to Guide Bridge, conveying ballast for Manchester Metrolink. Since this time, the class has fallen from grace with Freightliner and the majority of their fleet is stored out of use at Leeds.

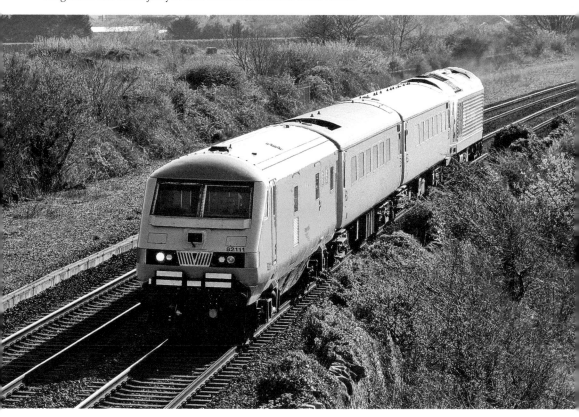

The plain line pattern recognition train is used by Network Rail to monitor track at line speed and saves many man-hours of traditional patrolling on foot. Formed of DVT No. 82111, two Mark 2 test coaches and locomotive No. 67018, the train passes Rhyl on 22 April 2015.

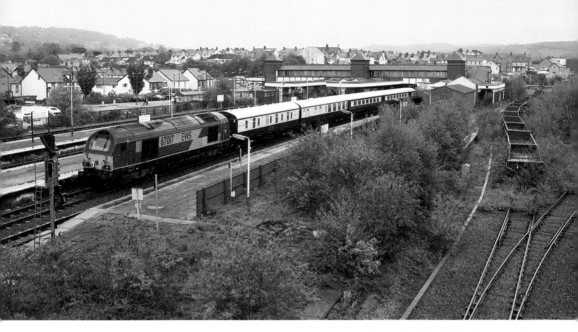

Class 67 locomotive No. 67017 at Llandudno Junction on 14 May 2010, working a Northern Belle charter with a Class 66 locomotive at the other end of the train. The heavily overgrown sidings on the right are all that remain of the once large Llandudno Junction motive power depot and goods yard.

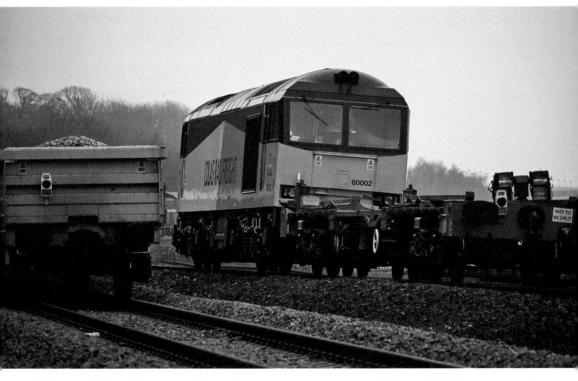

Colas-owned Class 60 No. 60002 at Mostyn during engineering operations on 21 January 2017. It was announced during the final stage of preparation of this book that Colas had sold their entire fleet of ten Class 60s to rival operator GB Railfreight for delivery by the end of August 2018.

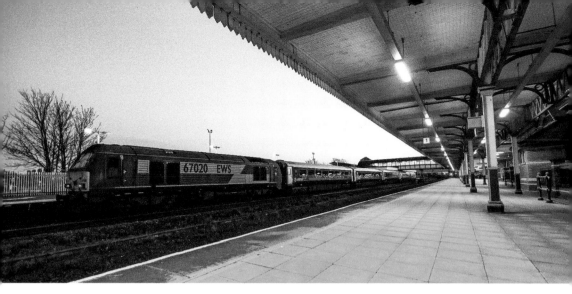

The new operator of the Wales and Borders franchise from October 2018 will be KeolisAmey and the company has announced the expansion of locomotive-hauled Welsh north to south services from late 2019. The current operation is seen at Rhyl on 18 April 2018, with DB Cargo-owned Class 67 No. 67020 pushing 1W96 to Holyhead.

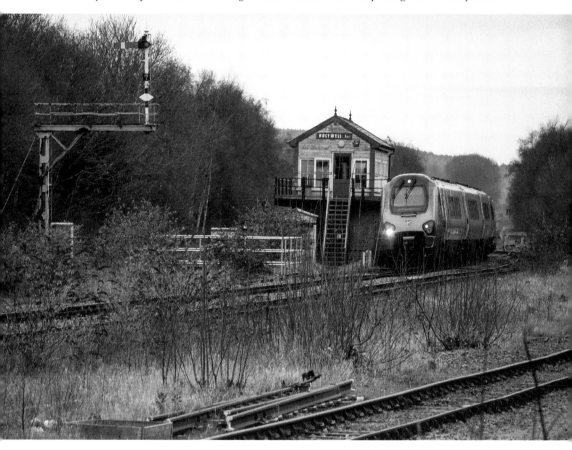

A Class 221 Voyager unit rattles through the foliage at Holywell Junction working 1A43, the Holyhead to London Euston service, on 21 February 2018. The Grade II listed box is now closed, but it's hard to think of any possible reuse for the building as it is situated between the running lines.

The hills and mountains that form the backdrop to the North Wales Coast main line see plenty of winter snow; however, it's a rare occasion to see lying snow on the tracks at sea level. One such occurrence was on 2 March 2018, with Manchester and Holyhead-bound trains passing to the west of Rhyl station.

The remaining island platform at Prestatyn handles all traffic at the station, the outer two platforms having been disused for many years. Class 67 No. 67015 calls with 1D34, the Manchester Piccadilly to Holyhead service, on 21 March 2018.

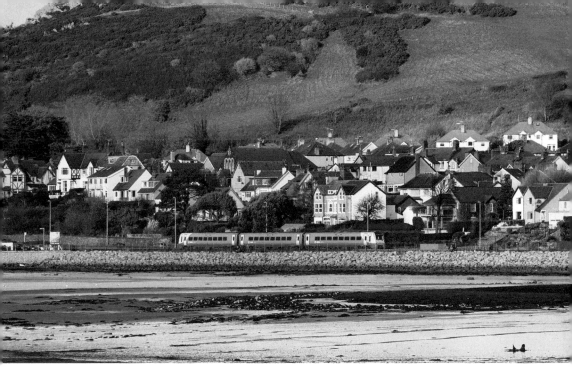

The Llandudno Town branch closely follows the Afon Conwy estuary for nearly its entire length. Deganwy Quay and marina are at the southern end of the branch and an afternoon train from Llandudno utilising a Class 175 is seen across the quay on 28 November 2009.

Unnoticed by the golfers, DB Cargo No. 67015 propels 1H89, Holyhead to Manchester Piccadilly, across the links at Prestatyn golf course on 19 April 2018. At the time of writing, it was uncertain if this working would continue beyond the change of franchise in October 2018.

The unlikely sight of a Class 50 hauling the Virgin Trains Pretendolino Mark 3 coaches at Llandudno Junction on 4 September 2011. The Snowdon Ranger Railtour utilised No. 50044 *Exeter* and Class 57 No. 57304 during its two-day stay in Wales.

Another occasional visitor is the Network Rail track assessment train, No. 950001. The two-car unit is based on the original Class 150 design and is generally utilised on lines where locomotive haulage is restricted or banned. The unit makes a mid-afternoon pass through Rhyl after use on the Conwy Valley on 2 December 2014.

West Coast Railways-owned No. 37516 powers a charter for Holyhead along the sea wall at Dwygyfylchi on 10 June 2016. Its *Loch Laidon* nameplates were previously carried by classmate No. 37214, another West Coast Railways-owned locomotive.

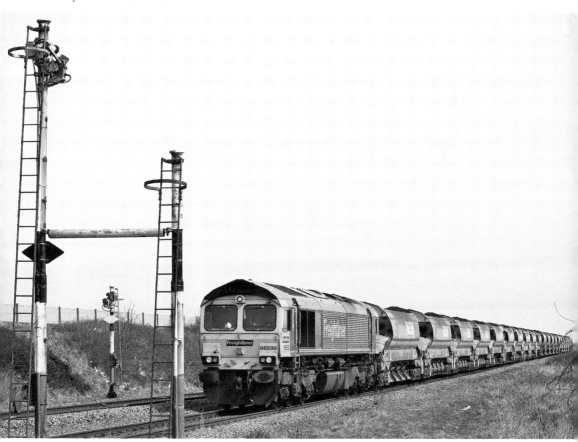

Surrounded by decommissioned semaphore posts, ballast train 6Y52 awaits its turn to drop fresh stone at Abergele on 8 April 2018. Class 66 No. 66590 heads the train, which had originated at Crewe Basford Hall during the previous evening.

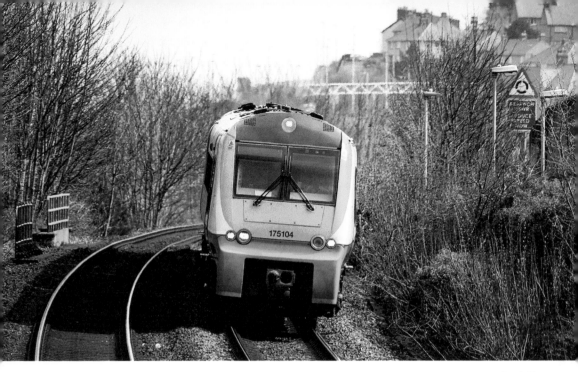

Class 175 unit No. 175104 curves towards the request stop at Llanfairfechan while working a morning Cardiff Central to Holyhead service on 11 April 2018. Now approaching their twentieth anniversary, the 175s have operated in the area since new.

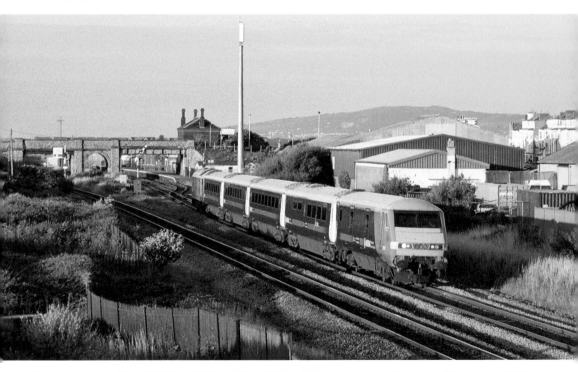

Evening shadows fall as DVT No. 82307 and Class 67 No. 67012 race through Abergele and Pensarn on 1W96, Cardiff Central to Holyhead, on 18 June 2015. The Class 67 had recently been released from passenger duty with Chiltern Railways and still wore the silver and grey main-line livery adopted by the company.

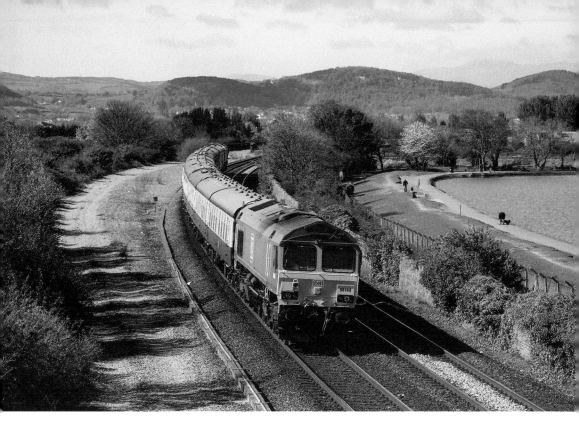

A relatively rare visit by a DB Cargo red-liveried Class 66 to the coast on 22 April 2017. Locomotives Nos 66105 and 66149 top and tail a UK Railtours charter from London Euston to Blaenau Ffestiniog as it passes the marine lake at Rhyl. The red locomotive will lead down the Conwy Valley after reversal at Llandudno Junction.

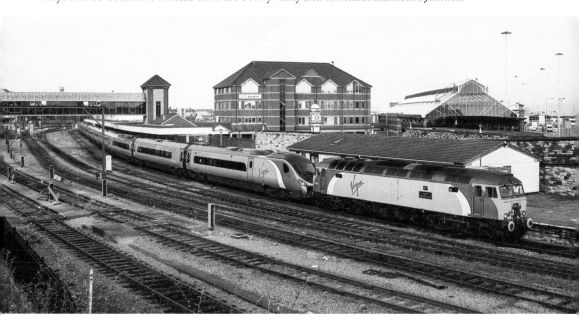

Awaiting departure time, 1A55 from Holyhead to London Euston sits at the port with Class 57 No. 57304 in charge. Classmate No. 57314 is stabled in the sidings to the left, waiting for its Monday morning run to Cardiff. Photographed on 31 October 2009.

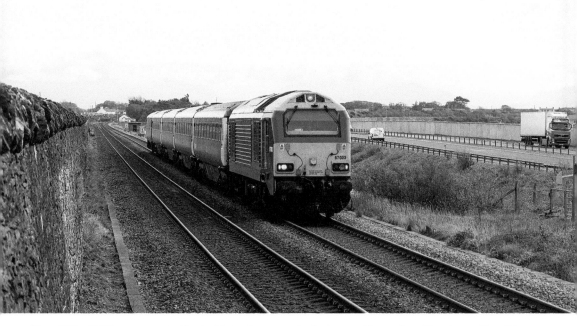

Class 67 No. 67003 passes over the Stanley Embankment on the final stage of its run from Manchester Piccadilly to Holyhead on 26 October 2016. The narrow cob is the only way to access Holy Isle from Anglesey and it carries the railway and both the A5 and A55 trunk roads.

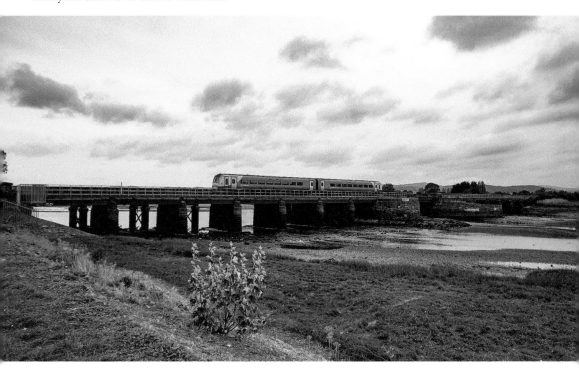

Formed of a two-car Class 175 unit, the 1H90 Llandudno to Manchester Piccadilly service crosses the Clwyd Viaduct at Rhyl on 24 October 2016. The viaduct had just undergone an extensive renovation and the new railings that replaced the previous cast-iron sides can clearly be seen.

Viewed from across the water at Pensarn Beach, the 1D34 Manchester Piccadilly to Holyhead service heads towards Llanddulas with Class 67 No. 67018 in charge on 20 March 2018. A clear day affords spectacular views from the hills above and, in the right conditions, Blackpool Tower can be seen on the horizon.

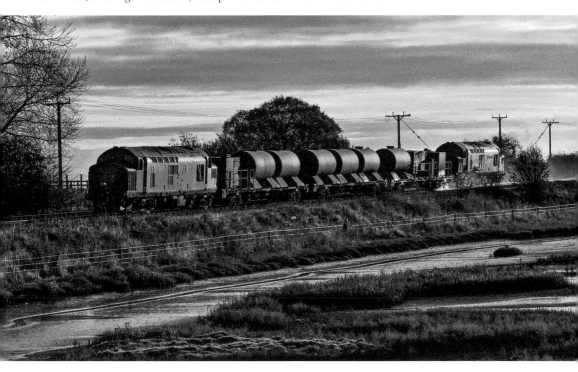

Subtly lit by a late sunrise, Network Rail's Nos 97302 and 97304 take the railhead treatment train west at Bagillt on 23 November 2013. At the time, the working was based at and operated from Crewe; from 2016 this work was moved to Coleham depot at Shrewsbury.

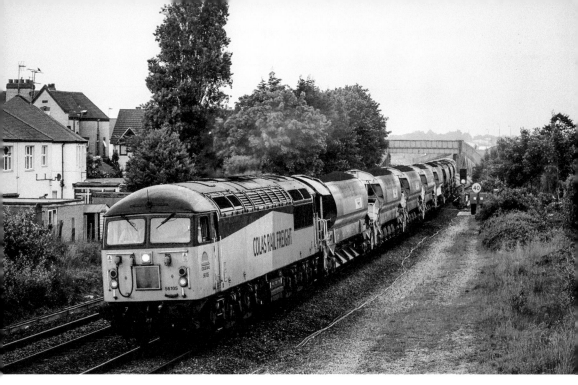

Colas Rail Class 56s Nos 56105 and 56078 top and tail 6C20, the Crewe to Holyhead ballast working, through Rhyl on 1 June 2018. At Holyhead, the train reversed to drop ballast along the up line across Anglesey.

Just a couple of days after closure, Rhyl No. 1 signalbox stands silent as 6K41, the Valley to Crewe nuclear flasks, passes on 28 March 2018. Handled by Class 66 locos Nos 66301 and 66425, this was the first occasion in around ten months that the train had not been worked by Class 68 locomotives.

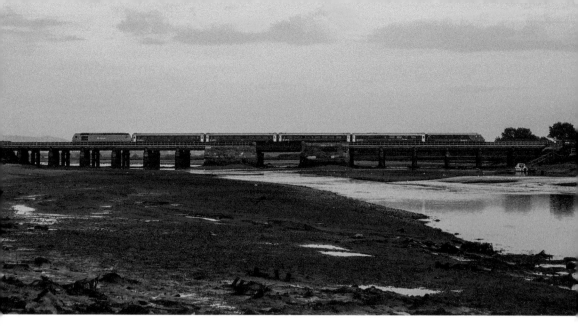

Low tide on 6 June 2016 as 1W96, Cardiff Central to Holyhead, is propelled west by red Class 67 No. 67013. The train will shortly pass the site of the former Foryd Junction, where the Vale of Clwyd branch to Denbigh and Ruthin, closed by 1962, parted from the main line.

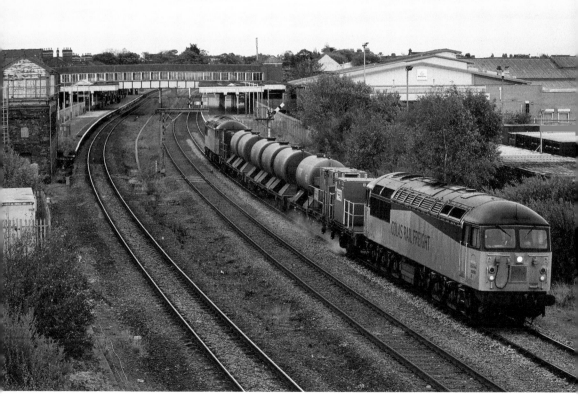

Colas Class 56s Nos 56096 and 56105 give the down platform loop at Rhyl a scrub clean as they pass on railhead train 3S71 on 14 October 2017. The rusty down through line was temporarily out of use due to damaged points; this line was restored to service early in 2018.

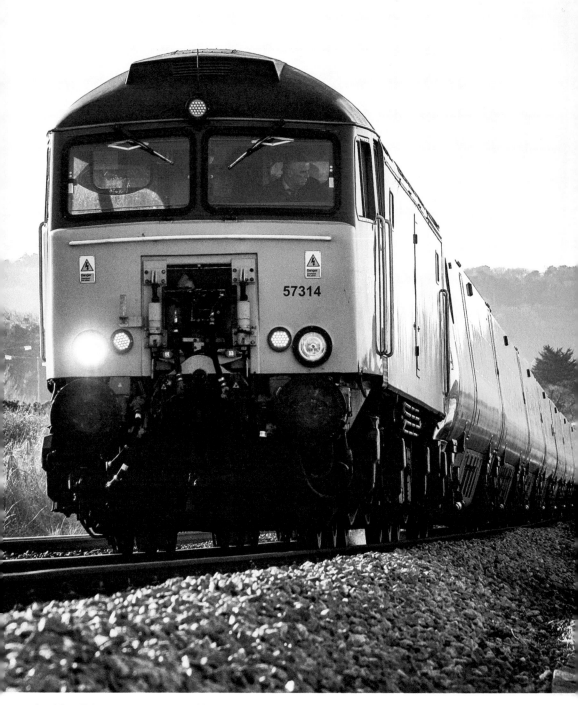

A cold 26 February 2011 sees Virgin Trains Class 57 No. 57311 getting to grips with 1A55, Holyhead to London Euston, at Colwyn Bay. Heading east from the bay, there is a stiff climb to Penmaenrhos tunnel, after which the line drops back to sea level at Llanddulas.

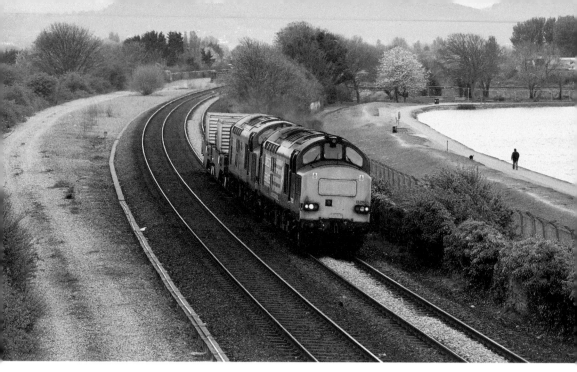

In the last weeks of Class 37 operation, Nos 37259 and 37602 pass the marine lake at Rhyl with two flasks on 6K41, Valley to Crewe. Seen on 21 April 2017, the pair are running about an hour earlier than scheduled.

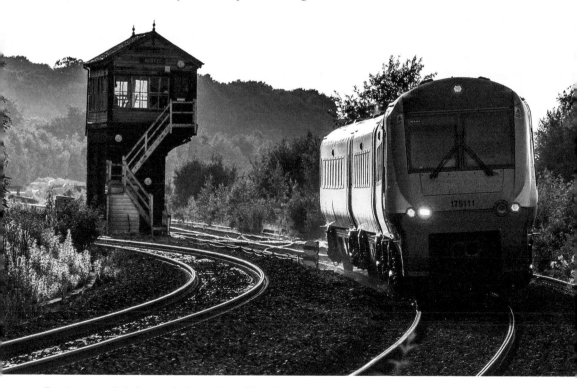

Evening sun and shadow catch the coaches of No. 175111 as it passes Mostyn signalbox heading for Manchester on 19 June 2014. The Class 175 train was perhaps the last design built that owed much to the British Rail Mark 3 coach from almost thirty years before.

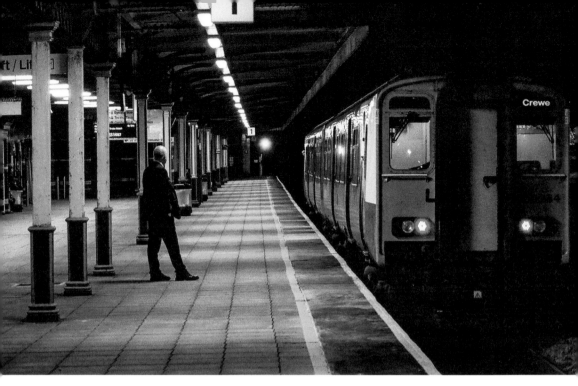

The Conwy Valley line unit works a late evening service to Crewe after finishing service on the branch for the day. On 14 April 2018, Class 150 No. 150284 was on duty and awaits its 10.16 p.m. departure time at Rhyl.

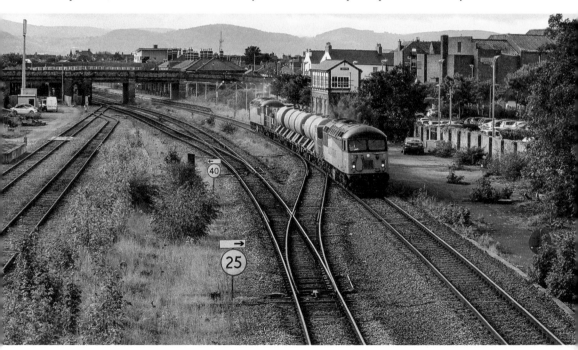

Sometimes you can't help but think that Network Rail are to blame for their own problems; the lineside vegetation in this shot has certainly grown unchecked for several years. The railhead treatment train helps, but it can't completely eradicate the problems caused by mulch build-up on the track. Colas Class 56s Nos 56113 and 56087 pass Rhyl No. 1 on 19 October 2016, taking 3S71 back to Shrewsbury.

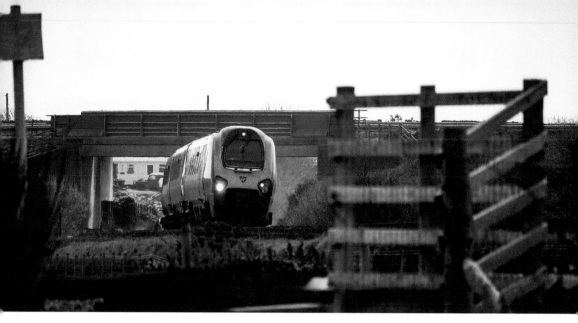

Framed on all sides, a Virgin Voyager passes the Valley triangle on 11 April 2018 working 1D82, London Euston to Holyhead. The 263-mile run from Euston takes around 3 hours and 45 minutes, an average speed of 70 mph.

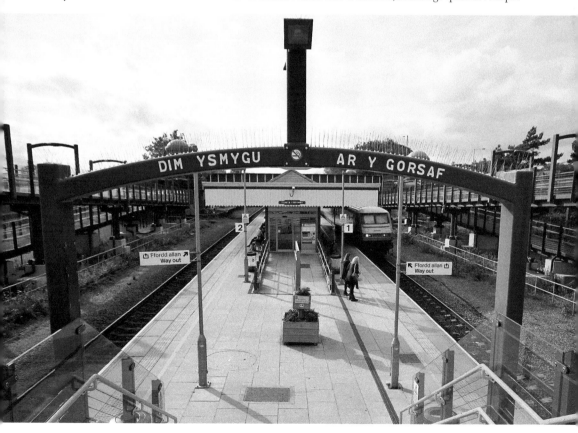

The recently refurbished Prestatyn station looks tidy as 1H89, Holyhead to Manchester Piccadilly, arrives on the up platform on 10 October 2017. The long bridge ramps have been built where the outer slow line platforms and tracks once stood.

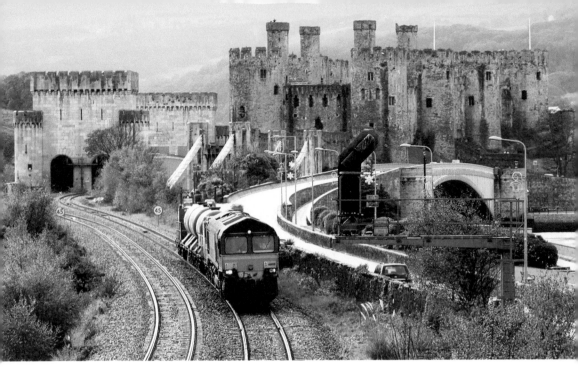

During the time that DB Schenker operated the railhead treatment train, Class 66 No. 66108 heads east at Conwy with a shortened single set formation on 4 November 2009. This was the last regular working for the DB Class 66 fleet along the coast.

Sunset is in full swing as a Virgin Voyager heads east at Ffynnongroyw, forming the 1G00 Bangor to Birmingham New Street train on 8 June 2016. After arrival into Birmingham, the unit will go empty to the depot at Central Rivers, near Burton-on-Trent, for servicing.

It's not common to see Class 175 units working in multiple on weekdays, such is the current shortage of stock. It does happen on occasion, usually after earlier disruption has left units out of place for the next day. The two-car unit on the rear of this Holyhead-bound train at Rhyl on 18 April 2018 had been attached at Chester to balance stock out after an earlier failure.

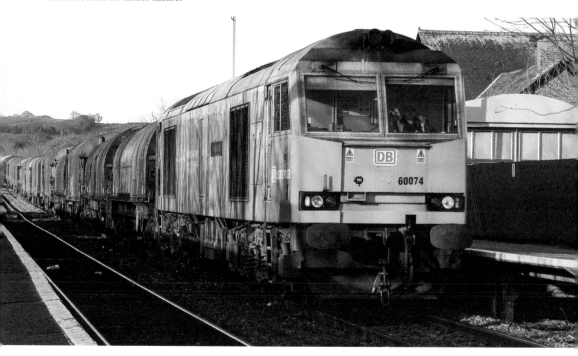

The overnight 6M76 Margam to Dee Marsh steel train rolls through morning shadows at Shotton High Level station on 20 April 2013 with locomotive No. 60074 in charge. This and the corresponding daytime working, 6M86, were regular trains for Class 60 haulage until the workings were taken over by Freightliner in 2017.

Roman Bridge station, the last stop before Blaenau Ffestiniog, on 5 June 2010. The former station building has made someone an excellent house, complete with its own platform and trains. The regular Class 150 approaches on its way to Blaenau from Llandudno.

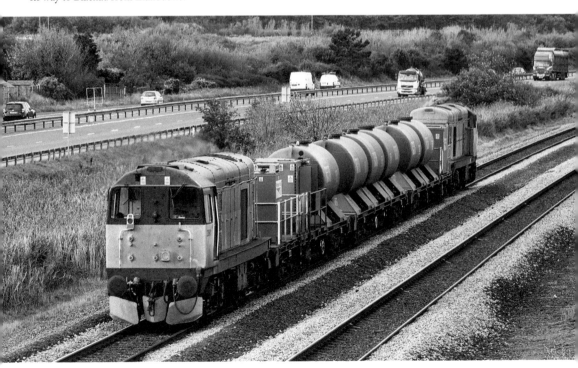

An early start to the 2011 RHTT season was made using Class 20 traction. On 29 September Nos 20905 and 20901 pass Abergele heading for Holyhead. The use of Class 20s was short-lived; by the following week the Network Rail Class 37s were in control.

Still water in the Afon Conwy reflects the ultrasonic test train at it heads north along the Conwy Valley line at Eglwysbach on 22 February 2018. Europhoenix-owned Class 37 No. 37611 propels the train.

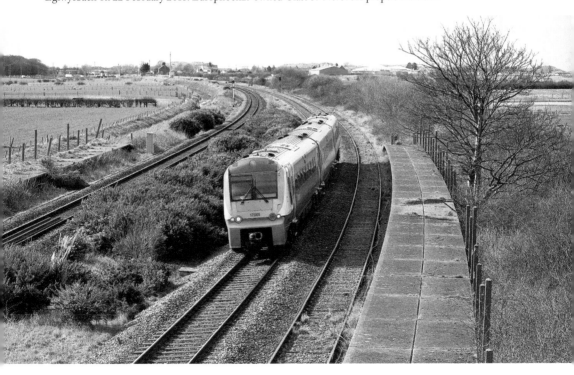

Closed since 1966, the concrete platforms at Talacre have stood disused for far longer than they ever gave service. The rusty track to the right is a remnant of the up slow line; its last use was as a long head shunt for trains accessing or leaving the Point of Ayr colliery sidings, which closed in 1996. Class 175 No. 175105 passes on 1V96 to Maesteg on 22 March 2018.

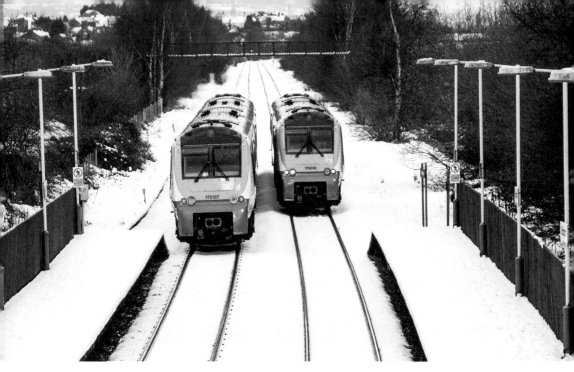

An unusually snowy Shotton Low Level on 25 March 2013 with Class 175 units on services to and from Llandudno. Despite the obvious weather difficulties, the services along the coast were running well; the only badly disrupted trains were those from London.

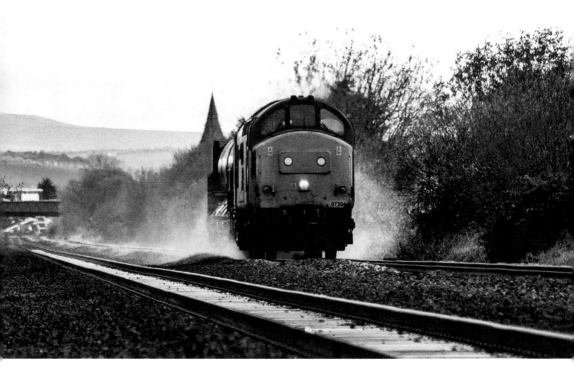

Another short-formed railhead train, this time on 12 November 2012. Network Rail Class 97 No. 97304 leads a single set east towards Prestatyn. At the time, the train was generally formed of at least six tanks with top and tail locomotives.

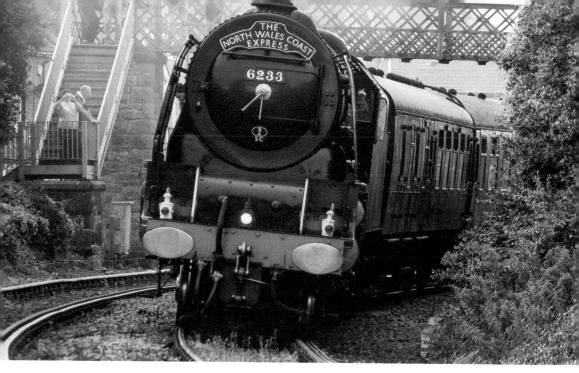

Not modern traction but certainly part of the modern scene, steam-hauled charters still attract plenty of custom as well as plenty of onlookers. The North Wales Coast Express is a regular sight on summer Sundays and is steam-hauled throughout North Wales. On 8 August 2010, LMS Stanier Pacific No. 6233 *Duchess of Sutherland* bursts into Deganwy station with the return working to Liverpool Lime Street.

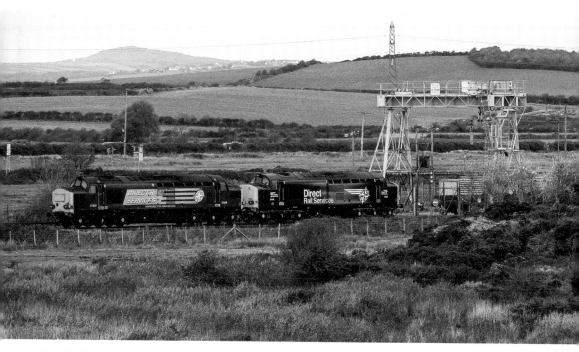

Two DRS Class 37s at Valley with two different liveries. At the front, No. 37259 carries the older style of 'Compass' livery while freshly shopped No. 37038 behind has received the latest house style. The locomotives await working 6K41 to Crewe on 26 October 2016.

Above: The more recent scene at Valley with Class 68 locomotives Nos 68026 and 68030 at the crane on 11 April 2018. The locomotives carry the basic blue livery and, as part of the fleet due to be sub-leased to TransPennine Express, will be re-liveried in due course.

Left: The sun sets on another day at Colwyn Bay on 6 June 2018 as a pair of two-car Class 175 units work eastwards on the 1K20 Holyhead to Crewe service. This currently is the last train of the day from Holyhead and the last but one eastbound through the bay.